Mastering Calligraphy

A complete guide · Tom Gourdie

Watson · Guptill Publications · New York

First published 1986 in the United States and Canada by
Watson-Guptill Publications, a division of Billboard
Publications, Inc., 1515 Broadway, New York, N.Y. 10036.

Library of Congress Catalog Card Number 85-40850
ISBN 0-8230-3020-2
ISBN 0-8230-3021-0 (pbk.)

Reprinted 1986

Manufactured in Singapore

Contents

About the author

Tom Gourdie, MBE, SSI, DA was taught calligraphy at the Edinburgh College of Art by Irene Wellington, and in 1939 was the first Scottish calligrapher to be elected a professional member of the Society of Scribes and Illuminators.

Mr Gourdie's work has been in the field of both handwriting and formal calligraphy. For his pioneering of the italic hand in Scotland he was honoured with an MBE in 1959. In 1963 he introduced the new handwriting experimentally to Swedish schools and this was officially adopted in 1971. He has also assisted with the introduction of a simple italic style to East German primary schools. He has made numerous trips to the USA and Canada to lecture on calligraphy and his modified italic, the Simple Modern Hand, and was guest of honour (the only one from outside the USA) at the Philadelphia Calligraphy Convention, June 1982. He has made two extended tours of Australia as a lecturer.

His books on calligraphy and handwriting have enabled many thousands throughout the world to enjoy those crafts.

To begin

TOOLS of the CRAFT * LETTERS

Labels on illustration (left to right):

Non Water proof black INK

One-stroke brushes

Fibre-tip lettering pens

Nibs of all sizes

Carpenter's Pencil

Pens for ultra-broad lettering

Fountain Pen Lettering Sets

Reservoir Holder (old type)

Lino-cutting Tool

T Square & Set Squares

Chinese Ink Stick

LETTERS may be written, drawn or carved. Written letters are usually done with a broad pen but may also feature the one-stroke lettering brush or lettering 'marker' pens. The broad pen can be a quill (goose, swan or synthetic) or of metal in a very wide range, some capable of producing very decorative effects. Drawn letters may be in single-stroke or skeleton form, using pen (ball-pointed), pencil or stylus, or they may be block or roman forms, first drawn & then filled in. Two pencils tied together produce thin & thick strokes similar to the broad pen. Painted or 'brush' letters are usually done with a fine brush freely manipulated, or with a broad brush or reed in the manner of ancient Rome and Pompeii, in which great dexterity was displayed.

Carved letters are cut into stone or wood or any other material (plaster, thick linoleum, plastic etc) after the letters are painted on with the broad brush or just drawn on, using mallet & chisel, knife or lino-tool (knife).

Lettering pens are available on cards (with a pen-holder) or in fountain pen sets. Poster pens in brass with a large range of widths & decorative effects are useful.

For roughs & preliminary practice, a carpenter's pencil may be considered. Inks for calligraphy are available already bottled but avoid waterproof inks – they clog and do not lend themselves to very fine work. Chinese ink sticks when ground in distilled water provide an ideal black. For colour use watercolours or 'designer's' colours. Powder colour, mixed with water to which a drop of gum arabic is added, is also ideal.

Roman lettering

LETTERING

in the ROMAN style began with CAPITALS which were first applied on stone with a chisel-edged reed, producing strokes of contrasting width, and then carved with the chisel. From the Roman Capital have sprung all the historic alphabets in a continuous development:

RVSTIC, UNCIAL, half-uncial Carolingian, Gothic and Italic styles

As the proportions of our capital letters were fixed by the Romans two thousand years ago so any lettering manual should begin with the roman capital. We follow this by a section illustrating the progression from a skeleton form to a simple broad-pen capital, to the orthodox roman and finally to a modern block capital, all observing these proportions. An analysis of form and spacing using the simple skeleton capital comes next and in turn is followed by a modern sanserif alphabet. The small letter is then introduced first in skeleton form as a guide to the development of a heavier letter which follows. All of this is an introduction to the broad lettering pen and the above alphabets. The equipment used for this section was a drawing board, T-square & set square, fibre-tip lettering pen, sable water colour brush & black (non-waterproof) ink.

ABCDEFI

GLMNOP

QVRTSX·I

Letters from the Trajan Inscription in Rome...

It cannot be disputed that the late Father Catich was an authority on the Trajan Roman inscription. His analysis of the letter forms is now accepted as is his supposition that the forms were influenced by the chiselled reed that was used to paint them on to the stone. Here is his version of the letters, but the alphabet was not complete hence H J K U W Y Z are missing.

Basic strokes & the alphabet

L Q S
B T A
E P G
D I C

as envisaged by Father Catich.

A B C D E
F G H I K
L M N O P
Q R S T V
X Y Z

The originals of these
letters are 16 cm tall.
They were written with a red sable, chisel-
edged, 'Brights' brush with no retouching
nor retracing of strokes, in a quasi-imita-
tion of the brush-layout method used by
the Roman sign-writing inscription mak-
er (librarius-quadrator) prior to chisel-
ling the letters in stone.

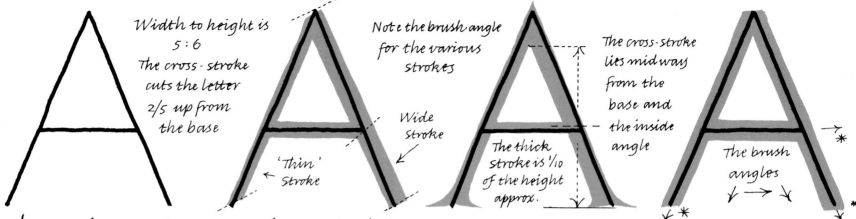

The carved roman letter was influenced by the broad chiselled brush, which made thick and thin strokes. The serif is essential to the roman letter – to do it the brush is held at this angle. The block letter was done with a broad felt pen, with the angle*changing according to the direction of the stroke.

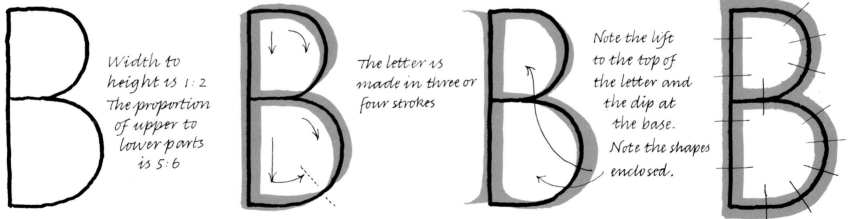

'B' is contained in half a square, the upper part being slightly smaller than the lower— but the difference should not be exaggerated. The shapes enclosed in the roman carved version require much skill to produce well. The one-stroke or block capital requires the brush be kept at right angles to the skeleton line as indicated.

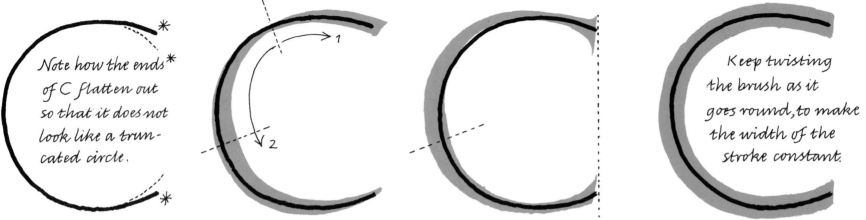

Note how the ends* of C flatten out so that it does not look like a trun-cated circle.

1
2

Keep twisting the brush as it goes round, to make the width of the stroke constant.

The outside curve of the carved roman letter is an almost perfect circle. The inner curve is slightly tilted to the left and the upper serif is a little heavier than the lower. A vertical line connects the outer limits of the serifs.

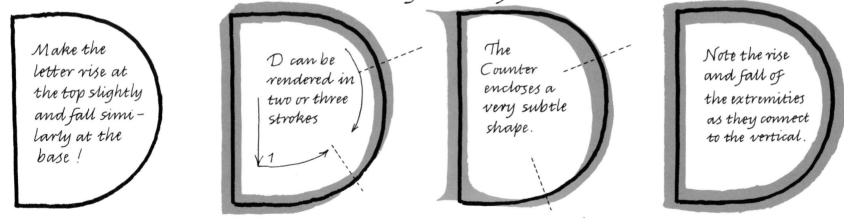

Make the letter rise at the top slightly and fall simi-larly at the base !

D can be rendered in two or three strokes

1

The Counter encloses a very subtle shape.

Note the rise and fall of the extremities as they connect to the vertical.

The outside curve of D, like that of C is almost a circle. The thin parts of the roman letter are less than half of the wide stroke. Like all the other round letters, D overlaps the guide lines slightly. Note the angle of tilt of both C and D which derives obviously from the angle the chiselled brush was held.

EFEFEFE

E is half a square wide. The centre arm of the broad pen version rests on the centre line, while the centre line bisects the lower arm of F. All versions place the lower arm of F a little below the centre arm of E which is also slightly shorter than the other arms—note the dotted line joining the letters. The upper arm of F is slightly longer than that of E.

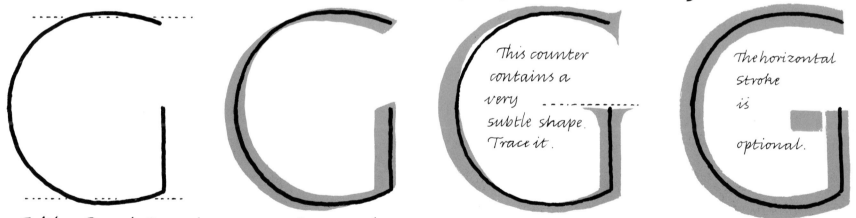

This counter contains a very subtle shape. Trace it.

The horizontal stroke is optional.

G, like C and D is almost a perfect circle but it is customary to compress it laterally so that it is not a mechanically made letter. The upright stroke comes up almost to the centre line. The inside shape, like the counters of B, C & D, is an extremely subtle one in the roman version. There is no need to add a horizontal stroke to the upright stroke, but you may.

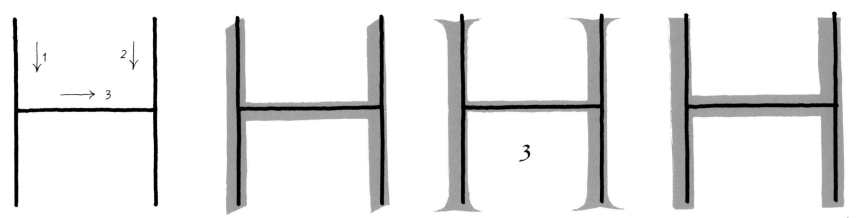

The proportion of width to height for H is approximately 7:8. The centre stroke of 3 rests on the centre line and here it has been made ⅔ as wide as the vertical strokes. This letter was not included in the Trajan inscription.

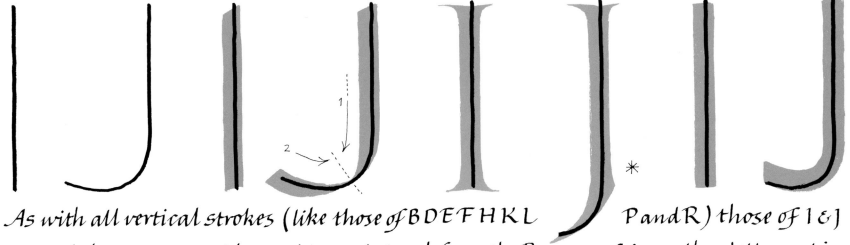

As with all vertical strokes (like those of B D E F H K L P and R) those of I & J are slightly concave, an idea we have retained from the Romans. J is another letter not in the Trajan inscription. It will be noticed that besides going below the line, J has been given a slight 'heel'.*

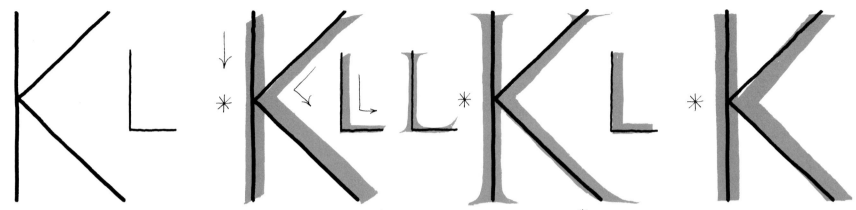

K is another letter not found in the Trajan roman. The chevron ⟨ sometimes just touches the vertical—here it locks on to it. The top stroke of the chevron is ⅔ of the broad stroke in width. K may be categorised as a medium width letter. C is just E minus two strokes.

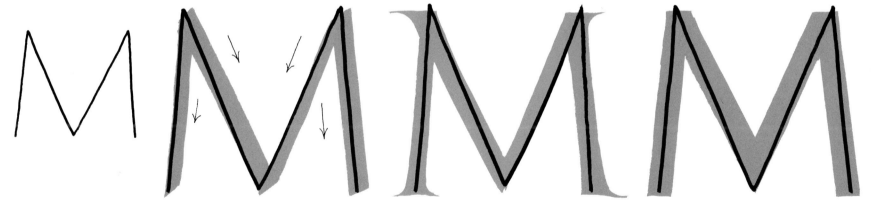

M is obviously a wide letter, with legs splaying slightly and with the V part coming down to the base line. The M of the Trajan inscription has angled tops but here serifs have been given to the letter, to make it easier to be produced by the lettering pen. If desired the V part may be taken only ¾ down e g : M or M.

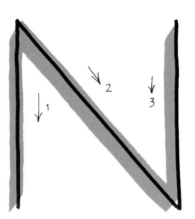
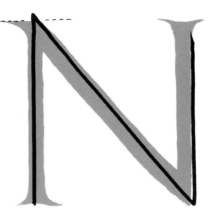
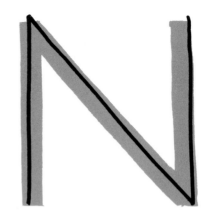

N is a medium width letter - approximately ⅞ of a square. The vertical strokes of the carved roman are ⅔ as wide as the diagonal stroke. When this letter has an angled top (here it has a serif) it projects above the line and the diagonal curves very slightly as it approaches the base.

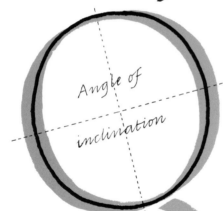
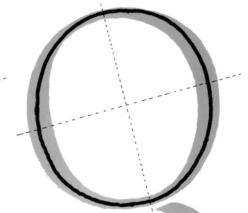

Angle of inclination

'O', like the other round letters is an almost perfect circle. The outside of the broad pen & roman versions is perpendicularly symmetrical but the inside is tilted. Q is just O with a tail which is joined to the 'O' at its thinnest point. The tail should have a graceful swing.

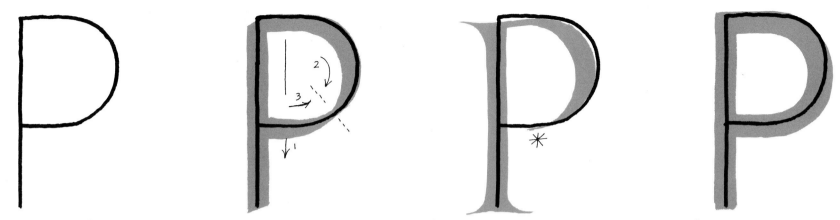

P and R are very similar in proportion, both fitting into ½ a square. The loop of P in the Trajan version* comes below the centre line ½ the wide stroke. Note the gentle rise of the loop from the top of the vertical stroke.

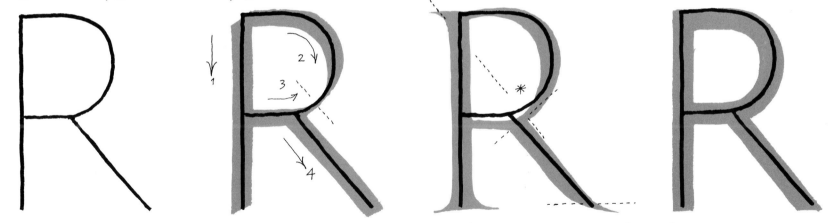

The loop of the Trajan roman R is deeper than that of P but in the other versions it is standard practice for the loop of P to be deeper. The 'leg' is placed in line with the upper serif and the loop tends to straighten out at the junction*, so that the join is made almost at right angles. The leg may project slightly below the base line.

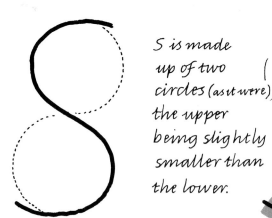

S is made up of two circles (as it were), the upper being slightly smaller than the lower.

Do the broad pen version in three strokes.

Note how this line slopes a little to the right

Note the vertical line here.

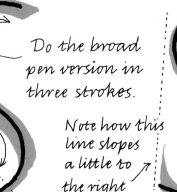

S is another letter fitting into ½ a square! It seems to have a forward tilt but this results from the lower part being slightly larger than the upper. The line joining the upper serif and lower curve is vertical whereas a similar line on the left is inclined slightly to the right.

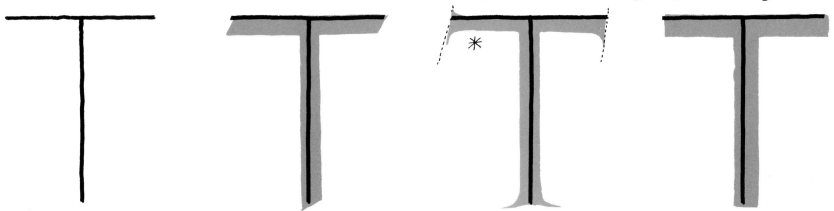

*

The proportion of width to height is approximately 7:8. The cross-stroke is ⅔ of the wide stroke in width in the Trajan roman version*. The angle of the serifs varies slightly, the left serif tilting a little more. The cross bar may also tilt down slightly to the right but neither of those features should be exaggerated.

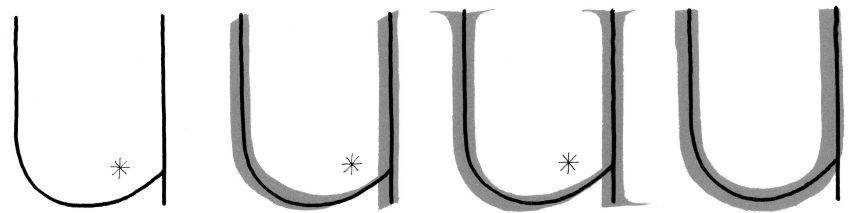

U is not included in the Trajan inscription – V was used for U. It is a medium width letter, made in two strokes. The first stroke flattens out*as it connects with the second one. The block capital is made as a one-stroke letter.

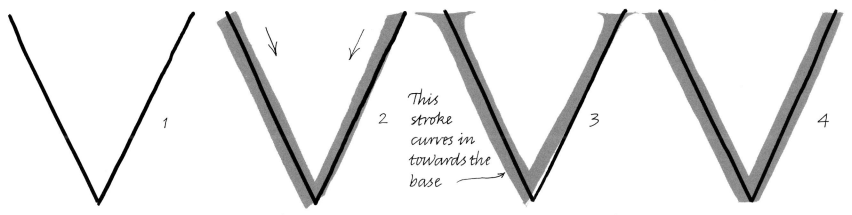

V is the roman U. In the Trajan roman it is slightly wider than A, but whereas the oblique strokes of A are straight, those of the roman V (3) curve in towards the base, to make the letter rest on the line instead of dipping below. Note the base of 4: ⊔ not V.

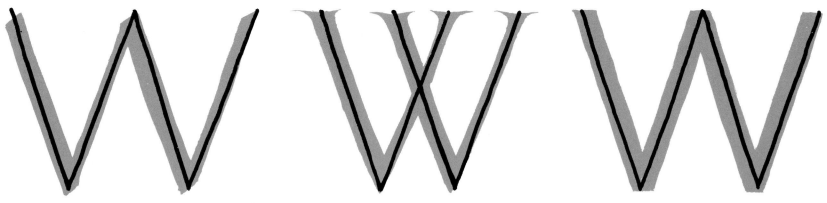

W should not be described as 'double U' but as 'double V.' Here the one-stroke brush version shows W without a break but the roman W has crossed Vs which have been rendered exactly as the previous V.

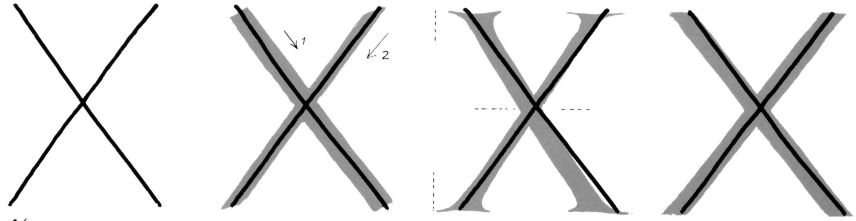

X occupies approximately a square in the roman version when one measures to the extremities of the serifs. The strokes cross on the centre line but the letter is slightly tilted to the right and the lower part is a little wider than the upper part.

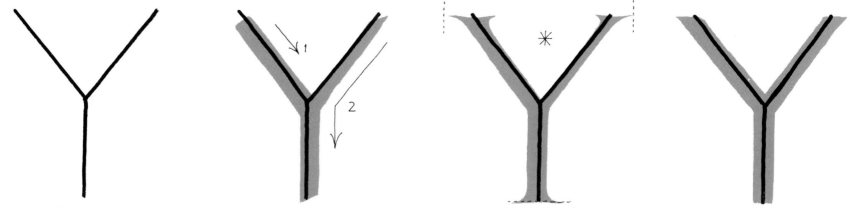

Another letter not found in the Trajan inscription is Y, which here occupies a square to the extremities of the serifs. The arms branch from the centre line. The width of the narrow stroke is ²/₃ of the broad stroke.

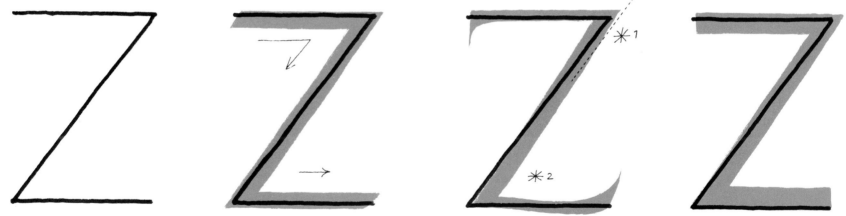

Z is also not included in the Trajan inscription. Like the other missing letters one has to imagine how the Roman craftsman would have rendered it — what subtlety he would have introduced to avoid a mechanical & wooden-looking letter. Perhaps he may have started the diagonal stroke with a slight curve[*1] and given the lower horizontal stroke a lovely swing[*2]!

VICTORIA

SIMPLE CARVING

SIMPLE CARVING will give you a much better idea of roman letters than painting them. The name above is a house-name which was incised on a slab of 'Battleship' linoleum. The letters are no more than 5 cms tall as the thickness of the linoleum does not allow larger letters. First draw out the name on paper, paying attention to spacing. Then on the reverse side of the paper rub black pastel crayon to provide a carbon-paper effect. Now take the linoleum, cut to the size of the paper (in this case 44 cms x 14 cms) and stipple white poster paint on to it. When the white dries, place the sheet of lettering on to the linoleum and trace the letters on to the whitened surface, using a sharp 'H' pencil. Go over the letters on the linoleum with the same pencil, making sure they are sharply and correctly drawn. With a sharp knife or scalpel, carve them out — holding the knife at an angle so that by cutting first one side and then the other you get a V-section and the part that is cut slips out easily. But cut carefully : do not alter the knife angle. Keep your hand steady.

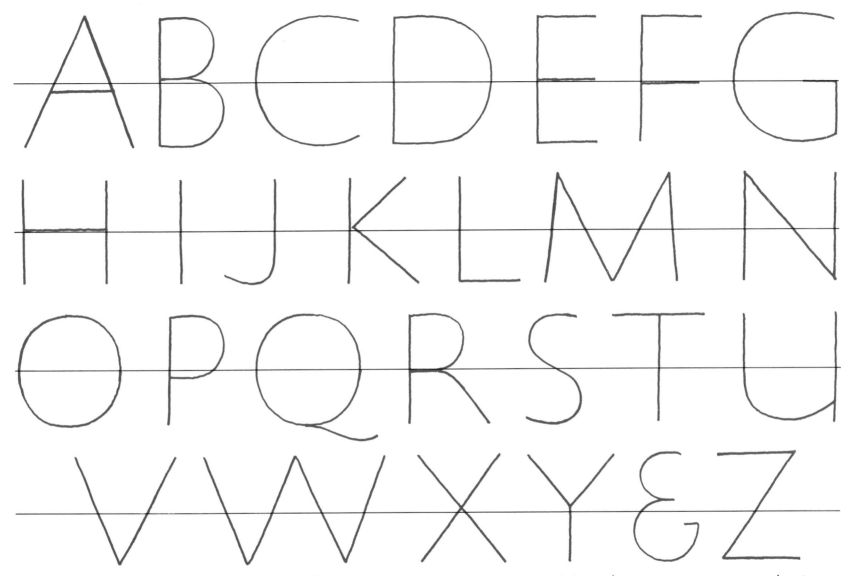

This basic alphabet observes the proportions established by the Romans in their carved inscriptional lettering. The line drawn through the centre helps to fix the position of cross-strokes (A E F G H) and depth of bowls (B P R).

Letters based on a square: M W or W

Letters ¾ of a square wide: A H N T U V

Letters ½ a square wide: B E F J K L P R S

Letters between ¾ & ½ a square wide: X Y Z

Letters based on a circle: C D G O Q

SPACING

letters is a visual exercise, in which the eye determines the area between letters so that they appear equally spaced out. It is not easy to do this but the following rules will help.

Vertical letters are widely spaced: INK

M-H-N-K

Vertical and round letters are brought closer: NO

M-O-N-K---S

Round letters are brought still closer : NOON

M-O-O-N-S

But when spacing letters we must also consider the open areas which are found in these letters:

LEFTY · CGS · KXZ : FLIGHTS

This calls for much manipulation of letters. It helps to view the letters upside-down to spot unequal spacing : SPACING LETTERS

POINTS TO REMEMBER

Round letters are not perfect-ly circular. They go above and below the guide lines a little.

Make pointed letters slightly taller so that they overshoot the guide line. Let S do the same.

Use the centre line to produce well-proportioned letters of the group BPREF, and of the group XYZ.

Note the slight rise and fall to the 'bowls' of B P R D. This avoids a too 'mechanical' construction.

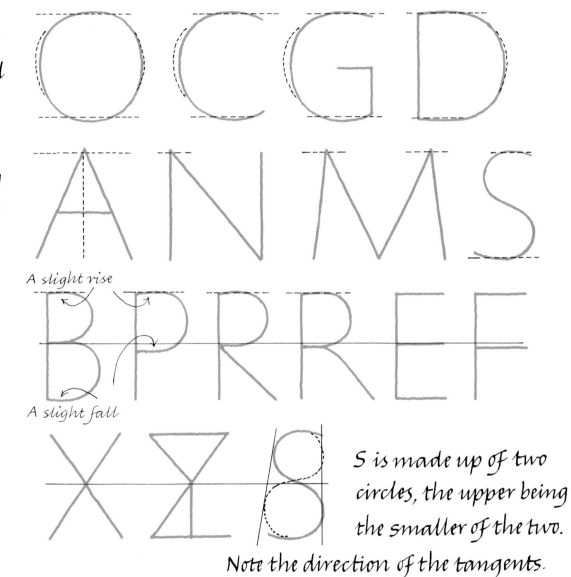

A slight rise

A slight fall

S is made up of two circles, the upper being the smaller of the two.

Note the direction of the tangents.

ADELAIDE
BRISBANE
CANBERRA
MELBOURNE

Spacing letters depends on how much is to be filled — plenty of room means spreading them & where space is short, they must be brought closer together & even compressed in form as in 'Melbourne.' Always remember that it is the area between letters that is important. It must always appear equal.

ABCDEFG
HIJKLMNO
PQRSTUV&
WXYZ

This sanserif alphabet is modelled on Eric Gill's but I have attempted to improve some of his letters, notably his M which has a very shallow V part. In the small sizes it appears too shallow. Here, the legs have also been splayed slightly instead of making them vertical. The filling in colour was done with a fibre marker 'calligraphic' pen in single strokes. The pen required constant twisting for the round strokes.

LIBRARY
SILENCE
PLEASE
FICTION
LITERATURE
DRAMA

For this lettering I used a fine sable-hair water-colour brush and poster colour. For an out-door job I would have used oil paint. The lettering was drawn in pencil with an H B pencil and then filled in with the brush.

Great care must be taken with spacing and getting the words centred — lettering cannot be rushed.

A vertical line dividing the inscription will help to place the words centrally disposed as you see here. Do the words separately, to get their length and then simply place them so that they lie equally disposed on the centre line.

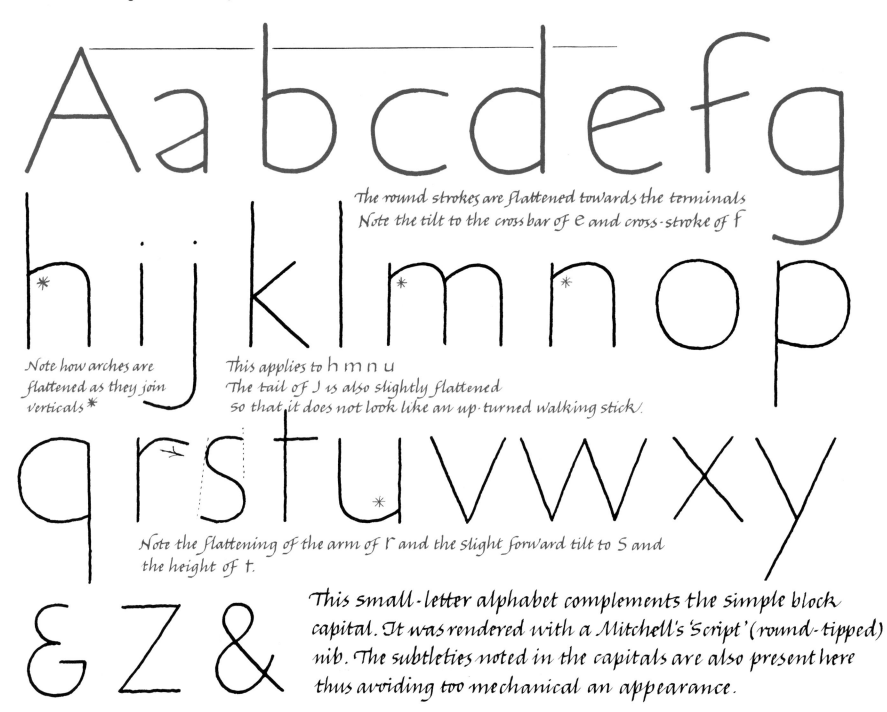

Aa b c d e f g

The round strokes are flattened towards the terminals
Note the tilt to the cross bar of e and cross-stroke of f

h i j k l m n o p

Note how arches are flattened as they join verticals ✱

This applies to h m n u
The tail of j is also slightly flattened so that it does not look like an up-turned walking stick.

q r s t u v w x y

Note the flattening of the arm of r and the slight forward tilt to s and the height of t.

e z &

This small-letter alphabet complements the simple block capital. It was rendered with a Mitchell's 'Script' (round-tipped) nib. The subtleties noted in the capitals are also present here thus avoiding too mechanical an appearance.

abcdefgh

Note how the rounded strokes are flattened
at the terminals in a b c d e f g *etc.*

ijklmnopq

b and q, d and p, n and u are examples of inverted forms.

rstuvwxyz

The 'block' small-letter alphabet is complementary to the 'block' capital. This was rendered with
an 0.5 Edding 1255 calligraphy pen (fibre-tip). Note the arches of h, m & n and how the stroke
narrows as it joins the vertical stroke – this also applies to u. There are subtleties to this alphabet
which indicate that this is not mechanically rendered lettering but a true art form.

abcdefgh

Note the slight swing out to the down strokes of a d h m n p q *and* u.

ijklmnopq

The ascenders & descenders are nine pen widths long. The x height is six pen widths.

rstuvwxyz

The small-letter alphabet complements the Trajan-based capital, and is rendered with the 0·5 Etting 1255 calligraphy fibre-tip pen. The serifs are made with the pen held at right angles to the writing line ↑, in two strokes ⌐ ⌐. The pen angle is altered considerably throughout the alphabet. This demands skill beyond the ability of most beginners, who are advised to come to this alphabet much later!

Italic lettering

ABCDEFG
HIJKLMNO
PQRSTUV&
WXYZ

The italic capital alphabet is characterised by its slope

which is here inclined at an angle of 8½°

This is the italic version of the Trajan-based capital alphabet. All the subtleties noted in the upright capital have been retained. The letters were rendered with the 0·5 Edding 1255 Calligraphic pen which is the only way one can realise the proper placing of the thick and thin strokes.

abcdefghi

Note the subtle shapes of the counters of a, b, d, e, g, o p and q.

jklmnopq

rstuvwxyz

This is the small-letter italic alphabet complementary to the previous capital and is calligraphic — in slope and tendency to ligature, as well as in economy of stroke. Thicknesses have been slightly exaggerated, giving the alphabet a distinctive character — notice especially a c d e g o and q. Note also how V W X Y have been given a similar finish,* thus providing a family trait.

The lettering pen

The broad nib is the ideal lettering tool as it provides a natural contrast of stroke. As an introduction to the broad nib, two pencils, bound together by a rubber band, may be used. This twin-pointed tool enables one to get the edge of the pen flat on to the paper, and, with the following exercises, shows if the pen is being held properly. Let the hand rest on its side and hold the pen between the thumb and forefinger with the middle finger acting as a support, then let the whole hand move the pen, the movement coming from the wrist.

Exercise 1 involves pointing the pen to the writing line at an angle of 45° and making upstrokes at 45° and down again at the same angle to produce the thinnest & thickest strokes. Exercise 2 shows vertical and horizontal strokes equal in width and 3 shows circles in two strokes, going from thin to thick and back to thin.

PATTERN-making as an introduction to the lettering pen is essential if one is to acquire sufficient skill with this tool to produce well-formed letters.

Begin with Exercise 4 to enable you to hold the pen at an angle of 45° to the writing line. The upstroke is the thinnest possible stroke and the downstroke the thickest. Exercise 5 should produce strokes of equal width if the pen angle is 45° to the writing line.

BORDER Designs

1

2

3

4

5

6

7

In the first & second of the designs shown here the pen is freely used, the patterns being made without lifting it off the paper. The third design is made by super-imposing 1 on 2.

The circles in 4 & 5 should be made in two strokes. In 7, curved & straight lines are combined.

An endless variety of stripe designs is possible with the lettering pen, especially if a second colour is used.

Vertical Stripes

ALL-OVER Patterns

Progress from border & stripe patterns to all-over patterns using squared paper

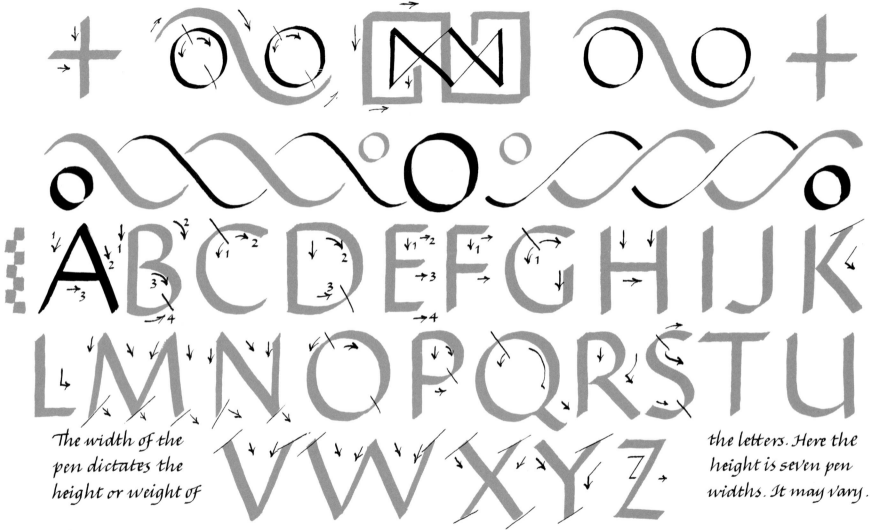

The width of the pen dictates the height or weight of

the letters. Here the height is seven pen widths. It may vary.

The broad lettering pen has to be held pointed at an angle of 45° (approx) to the writing line ↖, but it has to be altered for the narrow strokes of M N K V W X Y Z, either to make them lighter or heavier. All strokes are pulled, the numbers showing the order. Practise exercises such as those at the top of the page before trying the letters. I wrote them with a fibre-tip calligraphy pen.

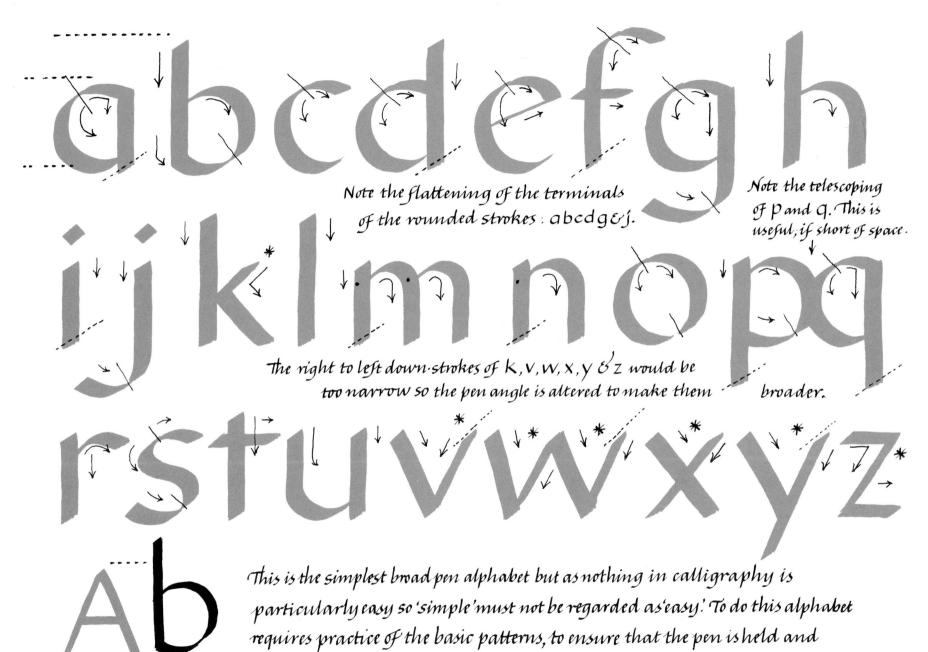

Note the flattening of the terminals
of the rounded strokes: a b c d g & j.

Note the telescoping
of p and q. This is
useful, if short of space.

The right to left down·strokes of k, v, w, x, y & z would be
too narrow so the pen angle is altered to make them broader.

This is the simplest broad pen alphabet but as nothing in calligraphy is
particularly easy so 'simple' must not be regarded as 'easy'. To do this alphabet
requires practice of the basic patterns, to ensure that the pen is held and
manipulated properly so that the angle can be altered where necessary (note the strokes marked by
an asterisk). The capitals are rendered not as tall as the ascender letters — here three quarters as tall.

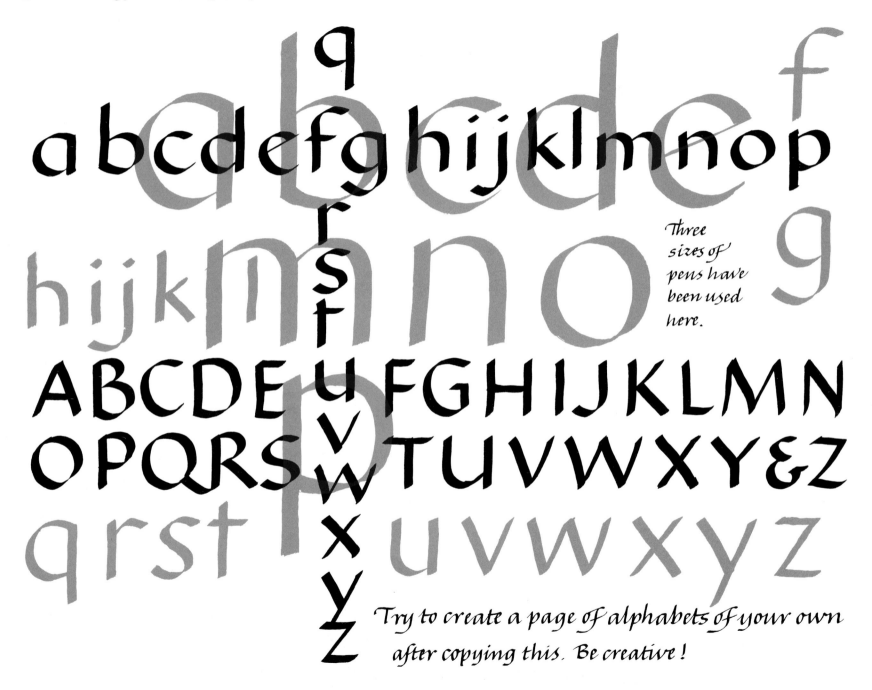

abcdefghijklmnop

hijk

Three
sizes of
pens have
been used
here.

ABCDE FGHIJKLMN
OPQRS TUVWXY&Z

qrst uvwxyz

Try to create a page of alphabets of your own
after copying this. Be creative!

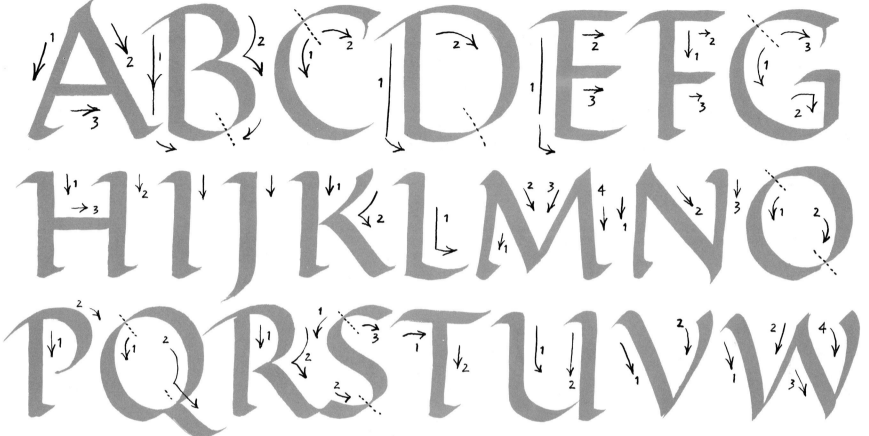

This is a simple serif version of the capital. The serif is just a pulled stroke of the pen, to start the down-strokes,

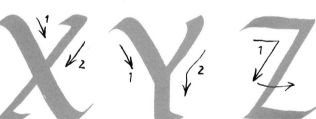

and it is also used as a pulled stroke to complete them. It requires care and skill to slide the pen along while lifting it off :- ⌐

There are various ways to make serifs at the base of the down strokes but the simple one used here is to be preferred : L rather than L or L . The weight of the letter alters according to the number of pen widths to the height. The top line is 7 widths tall, the rest only 5½ widths.

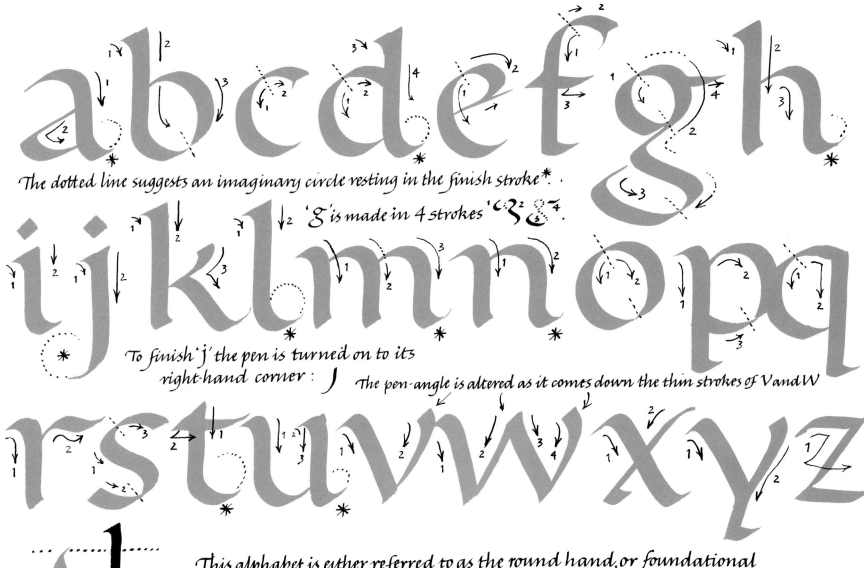

The dotted line suggests an imaginary circle resting in the finish stroke.*

'g' is made in 4 strokes

To finish 'j' the pen is turned on to its
right-hand corner : J *The pen-angle is altered as it comes down the thin strokes of V and W*

This alphabet is either referred to as the round hand, or foundational
hand (Edward Johnston's term) and is based on the 10th century Caroling-
ian minuscule (small letter). The circle is the obvious form of this alphabet,
including the finishing strokes of adhiklmntux&j. The serif is made in two strokes:
C and f are given finishing 'flick' strokes ~ the pen is turned on to its edge & drawn down :

ABC a DEFGHIJKLM
b
et c ghïjklm
d
e
f
g

NOP h nopqrstu
QRS i
TUV j vwxy andz
WXY k
&Z l lmnopqrstuvwxyz

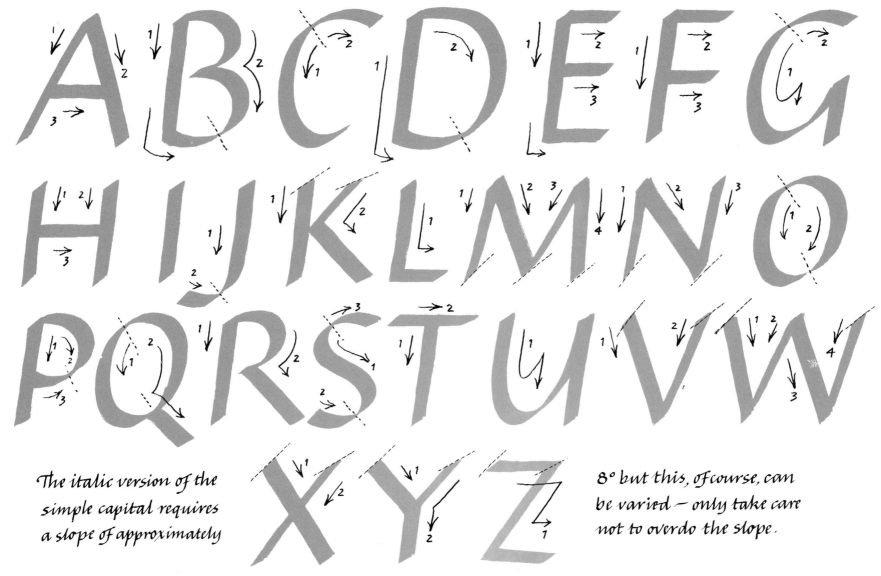

The italic version of the simple capital requires a slope of approximately

8° but this, of course, can be varied — only take care not to overdo the slope.

As with all alphabets, care must be taken to get uniformity — here, of slope, structure and character. The pen-angle has to be manipulated on occasion either to increase or decrease the stroke width, particularly of the right to left down strokes of K M N V W X Y and Z.

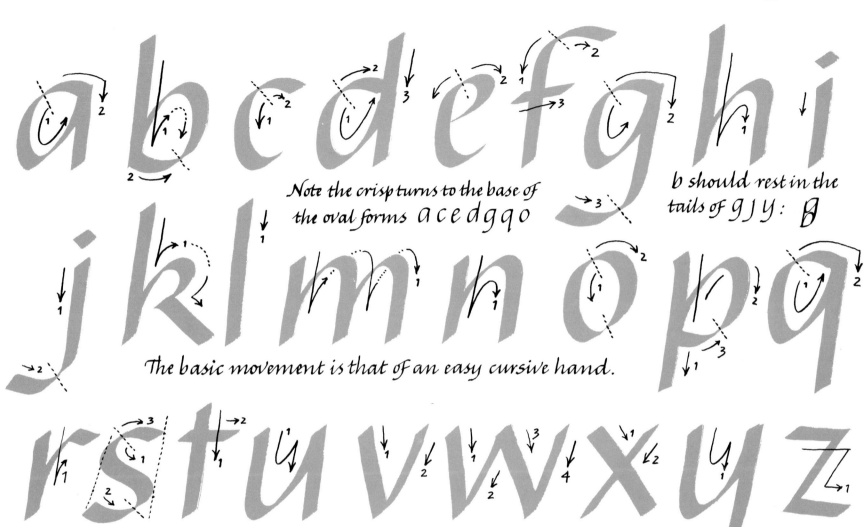

Note the crisp turns to the base of
the oval forms a c e d g q o

b should rest in the
tails of g j y : ß

The basic movement is that of an easy cursive hand.

Note the tilt of s ~ how the tangent from the start of the letter to
the lower curve slopes at the same angle as the vertical strokes.

The characteristics of the minuscule italic should be grace and lightness — a cursive flow is
suggested by the slope which should be the same as for the capital. To achieve this sense of light-
ness the turns of the downstrokes of a c d e g o q u y (c v) should be made quite crisp, not
rounded, and the hand allowed to manipulate the pen as for handwriting.

a b c d e f g h

A G H I J K L M
a
B D d N O P
b E F f Q
C e R
S T U V
C W X Y AND Z

i j k l m n o p q r s t u v w x y z

Here are the simple italic capital and small-letter alphabets done with the fibre-tip calligraphic markers.

ABCDEFGH
IJKLMNOP
QRSTUVW

ABCD XYZ EFGHI
JKLM NOPQR
STUV WXYZ

The italic capital rendered with
increasing swing produces what
is called the swash capital.

abcdefghi
jklmnopq
rstuvwxyz

This minuscule italic is used unjoined but it does not need a
great stretch of the imagination to realise it written cursively, with letters joined
diagonally as the written text. But its beauty lies in each letter being properly
formed and carefully spaced : floral art, sloane street, sw1.

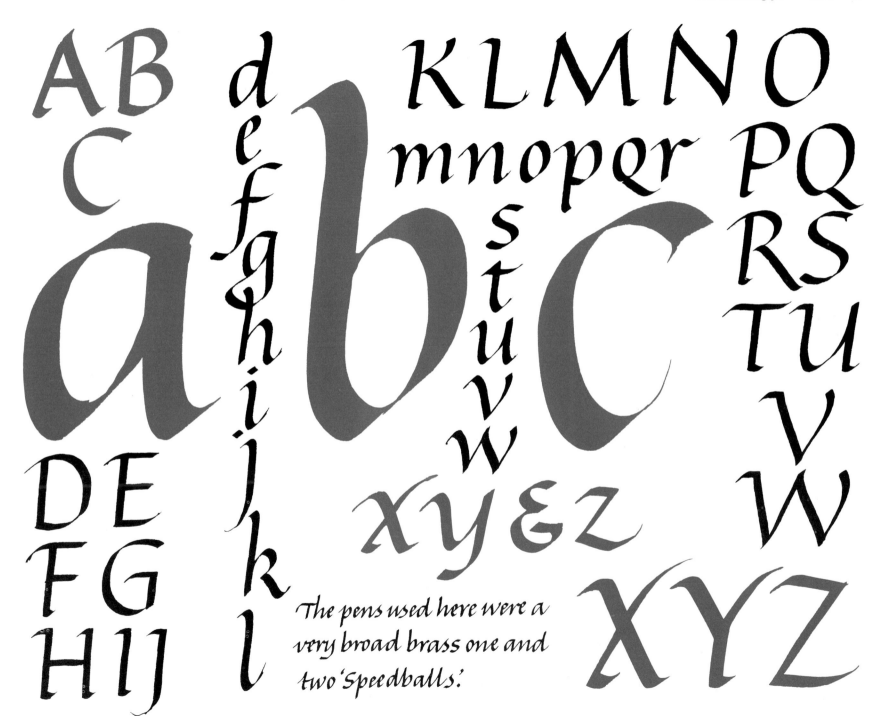

AB C DE FG HIJ

d e f g h i j k l

KLMNO mnopqr s t u v w xyɛz

The pens used here were a very broad brass one and two 'Speedballs'.

PQ RS TU V W XYZ

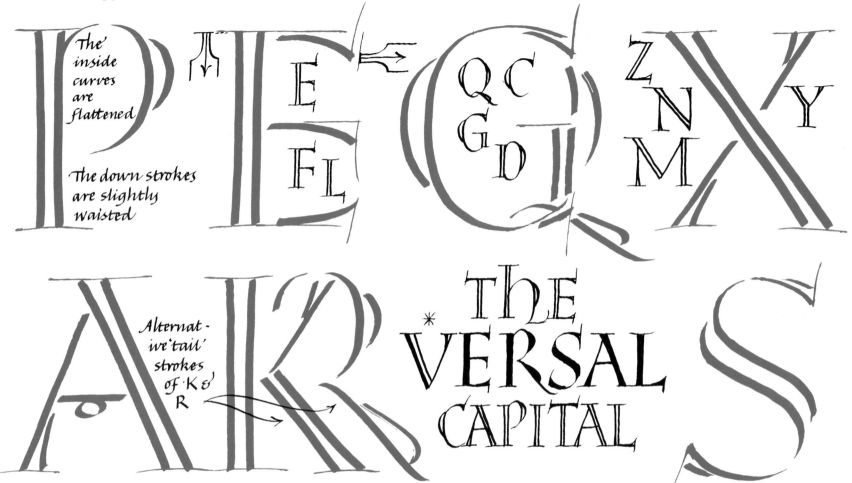

The versal capital is built up with the broad pen, and a fine width is recommended. The broad strokes are made of two strokes tapered in at the waist (but only slightly!). As a general rule the pen is held pointed towards the body for all vertical strokes and parallel to the body for horizontal strokes. The letters may be left open* (showing the construction) or may be filled in. Ordinarily the versal capital is used singly to begin verses and paragraphs & for those occasions demanding extra emphasis, but in mass it is also impressive.

A B C D E F G H I J K
L M N O P Q R S T
U V W X Y Z

Once the roman letter forms
have been mastered and the
simple versals practised then
one may indulge in decoration, as below, particularly when using two colours.

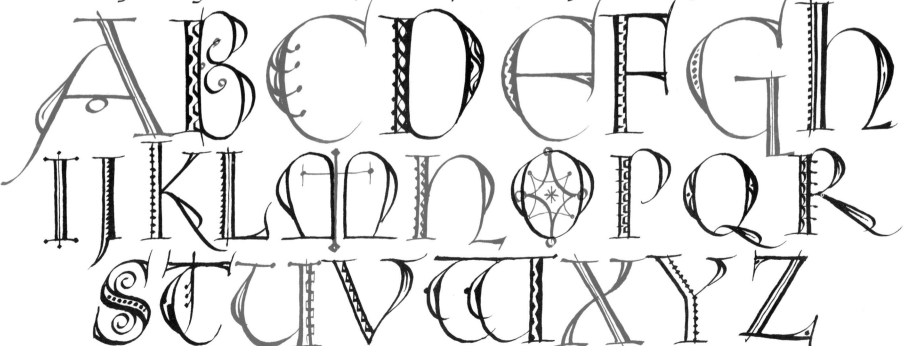

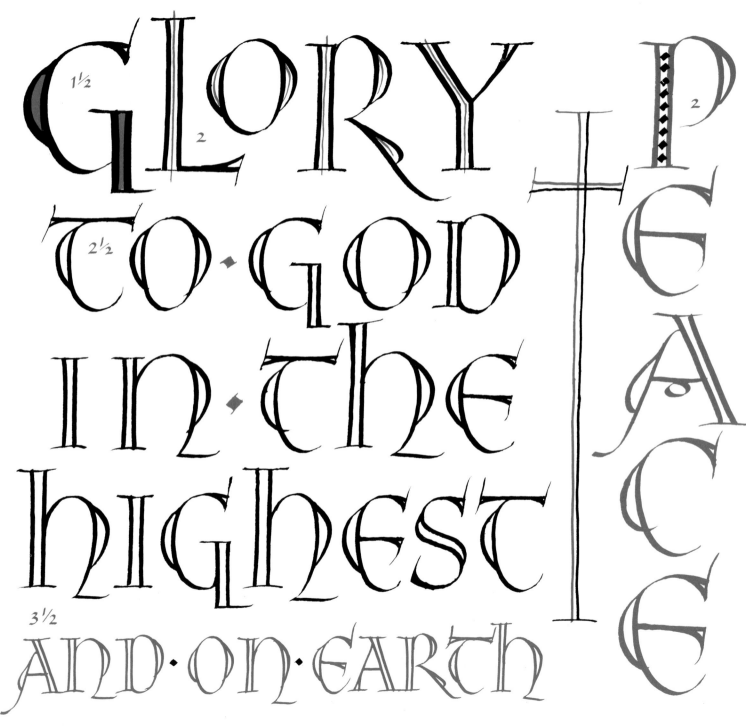

GLORY TO GOD IN THE highest AND·ON·EARTH PEACE

1½
2
2½
3½
2

The Versal
Capital makes
for a very decora-
tive effect in a panel,
as seen here.
The pens used
were the Rexel
Round Hand
Nos 1½, 2, 2½ &
3½, as indicated
by the numbers.

ABCDEFG
HIJKLMNOPQR
STUVWXYZ

This is another variation of the versal. Open ended strokes lend a modern look to the old form.

ABCDEFGHIJK
LMNOPQRSTVWXYZ

This alphabet is derived from the painted inscriptions of David Jones. The Trajan influence is clear.

ABCDEFGHIJK
LMNOPQRSTU
VWXYZ

*This alphabet, which closely follows the Trajan roman, is a version of what is known as the quadrata or square capital and is a pure pen form. The pen is manipulated by twisting it on its axis to produce some of the serifs — not an easy thing to do, particularly those serifs of the arms of E, F and L. The pen angle indicated * is essential to this alphabet.*

ABCDEFGHIJKL
MNOPQRSTUVWXYZ

This is another version of roman capitals, with the merest hint of stroke contrast.

ABCDEFGHIJK
LMNOPQRSTUV
WXYZ

V served for U in the original alphabet

RVSTIC CAPITALS

The rustic capital was a bookhand of antiquity. It was also the style the people of Pompeii were accustomed to, as notices, public announcements, etc were inscribed on the walls in this alphabet. It was painted directly (& most expertly) on the spot with a chiselled reed. It had great beauty. The rustic letter was, unlike the quadrata, made of the fewest possible strokes, with the reed pen held almost horizontally ←, so that the vertical strokes are narrow and the horizontals broad. As a book hand it had obvious economic advantages, being so compressed that much more could be written in a given space compared to the square capital. Note how the down strokes narrow as the pen descends by altering the pen·angle from ← to this ←.

OVR*FATHER
WHICH·ART·IN·HEAVEN
HALLOWED·BE·THY·NAME

Thy kingdom come. Thy will be done in earth
as it is in heaven. Give us this day our daily
bread. And forgive us our debts, as we forgive
our debtors. And lead us not into temptation,
but deliver us from evil. For thine is the king-
dom, and the power, and the glory, for ever

A*M*E*N

AFTER THIS MANNER THEREFORE PRAY YE
*

This illustrates
how the rustic
capital was blended
with 'text' hands.
This example shows
a modern version
of the Carolingian
book hand. It was
inspired by
Edward Johnston's
foundational
hand which he
based on the 10th
century
Carolingian used
by the English
Scribes.

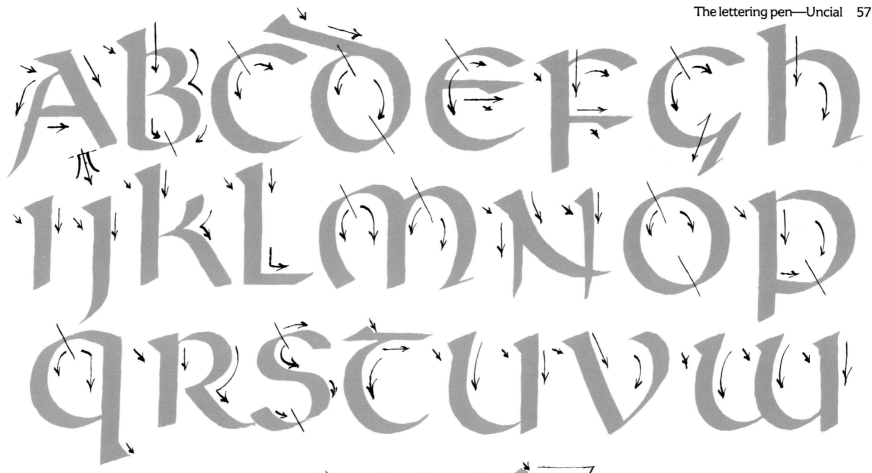

The uncial alphabet is in complete contrast to the rustic capital. It is based on the circle and is therefore space consuming, but it is also a pure pen alphabet.

All the strokes are natural to the hand, and rendered freely. In devising a modern version one must appreciate the elements, the 'spirit' or characteristics of the style. The pen angle is almost opposite to that of the rustic — this ↑ compared to that ↖ . It lends itself to a great variety of interpretations and is therefore a favourite modern alphabet.

abcdefgh

ijklmnopqrr

stuvwxy&z

This is the half-uncial alphabet, modified, of course, for present-day use. The pen-angle is almost flat—about 5°. Tuck the elbow well in for ease in doing this alphabet. The serifs are made in two strokes and are a prominent feature of this style. Note the slightly curved vertical strokes of b, l and t, and also of U, W and y. A slight swing has also been given to the descenders of g and y. The half-uncial was used by the Irish Scribes of the 6th to the 9th centuries and was perfected to a very beautiful form which was the alphabet used for the text of the Book of Kells, now in Trinity College Library, Dublin.

abcdefghijklmno
pqrstuvwxyyz

abcdefghijklmno
pqrᴢ2ſstuvuuxy&z

abcdefghijklmnopqrstu
vwxyz

These are variations of the round or book hand. The first is a compressed version of a 9th century Carolingian script, the second is also 9th century (English) but the third is the Italian 15th century Carolingian inspired book hand. It was so mechanically precise that it may often be taken for a printed rather than written letter. The first Italian printing type-faces were inspired by this script. Modern scribes make use of these alphabets, modifying them, of course, for present day use.

abcdefghijk

lmnopqrstuvw

xyz,z,tt

The rounded Carolingian hand gave way to a very compressed and angular alphabet which echoed the change in architecture from the rounded Norman arch to the pointed one of Gothic. This style persisted for centuries, becoming looser as time went on, as was to be expected of any austere alphabet.

The space between the down-strokes was very often just the width of a stroke so a dense effect resulted, hence the term **black letter**, and naturally the clarity and legibility of the Carolingian gave way to something far from easy to read, especially when i's remained undotted as we see in the word 'minimum': minimum

ABCDEFGHI
JKLMNOPQRSTU
VWXYZ

It is customary to make the capitals not so tall as the small-letter ascenders so this rule will also apply to Gothic.

ABCDEFGHIJ
KLMNOPQRSTU
VWFYZ

Both capitals shown here are suitable for use with the simple small-letter alphabet.

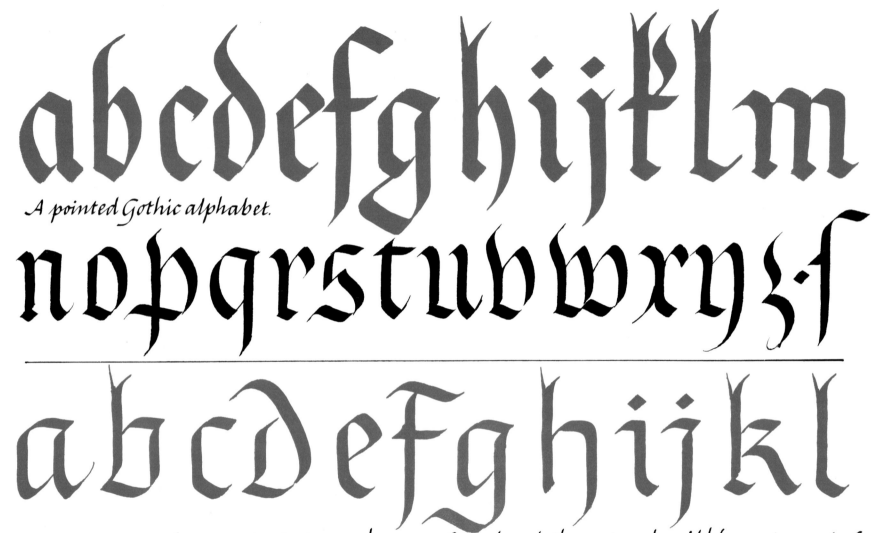

A pointed Gothic alphabet.

A more cursive Gothic in which the angles are softened and the natural scribble movement of the hand has been allowed to dictate the form of the letters.

ABCD
EFGHIJ
KLMNO
PQRST
UVWX
YZ

ABCDEFG
HIJKLMN
OPQRSTU
VWXY
Z

The
two alphabets shown here are
much less ornate than many of the
'fractur' alphabets one finds in type speci-
men books. A little decoration goes a long way
and too much can so easily spoil an
otherwise fine alphabet. The expertise of two German
scribes, Hermann Zapf and Hildegard Korger,
can teach us much.

abcdefghijkmlnopqrsstuvwxyz

Glotzt nicht so roman- tisch! Brecht

ABCDEFGHIJKREMNPQ. RSTUVWYXZ 1234567890

Hildegard Korger (East Germany)

iinmubopqrwoyc y g k o textura

ABCDEFGHI JKLMNOPQ RSTUVWXYZ 1234567890

abcdefghijklmnop qrlstuvwxyz

Hermann Zapf (West Germany)

from 'Inleiding Tot De Calligraphie (Holland)

Adam bertil cæsar david elbe fauſt
amedok niklas ornat jonas kagor
pech quintus ſebald thüringen vogeſen
urban wodka xerxes yſop za Hamburg

abcdefghijklmnopqurſſtuvwxyz

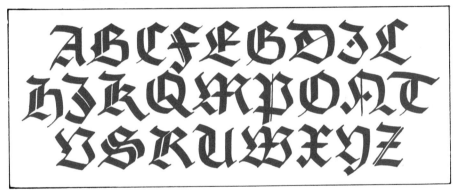

Das Schwere iſt der Kampf, aber der Kampf iſt das Vergnügen. Romain Rolland

ABKDESLGNÓZE

abcdefghijklmnopqrsſtußvwxyz

Rose, o reiner Widerſpruch, Luſt, niemandes
Schlaf zu ſein unter ſoviel Lidern.

Hildegard Korger

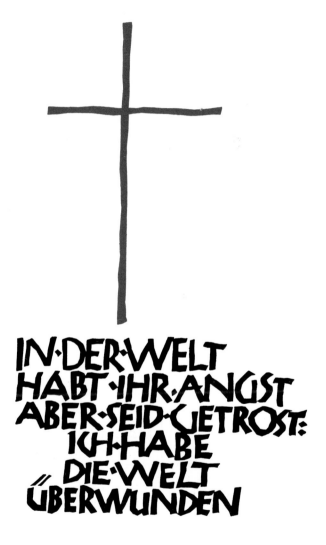

IN·DER·WELT
HABT·IHR·ANGST
ABER·SEID·GETROST:
ICH·HABE
DIE·WELT
ÜBERWUNDEN

Rudolph Koch

Layout of the page

Here are some rules which should be observed for good layout

(1) *Frame the writing on the page so that margins are proportion-ed 2:3:4 (top to sides to base). This applies to a single page.*

(2) *Frame a double-page so that the proportions of the margins are 2:3:3:4 (top to sides to centre to base).*

(3) *Folding paper for a manuscript book: one fold is called a folio, folded twice produces a quarto fold and folded yet again produces an octavo fold.*

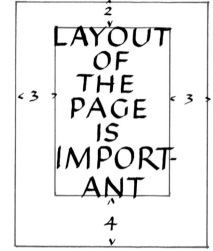

Sheet *folio*

quarto *Octavo*
(4 to) *(8vo)*

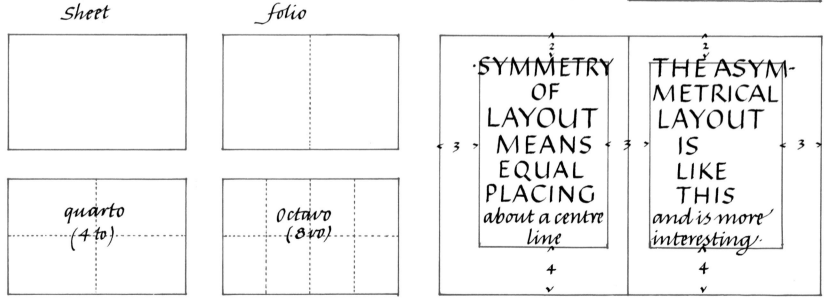

The shape, size & margins of the page together determine the length of the writing-line and the size of the writing should be such as will allow a reasonable number of words to the line. Eight or nine words to the line may

Writing may be massed as here to produce a dense effect with hardly any room for ascenders & descenders

or

Writing may be light in texture allowing for long ascenders and descenders as in this Italic example.

or

C A P I T A L S · M A Y · B E · S P R E A D ·
O U T · T O · P R O D U C E · A · L I G H T ·
A N D · D E L I C A T E ·
E F F E C T

be regarded as the ordinary maximum. On the other hand, lines can be too short and it is suggested that the minimum should be four or five words.

Writing need not be staid & sober, sticking to ruled lines, so, if the piece demands a joyously free treatment, be like Ann Hechle:

WHO CAN SAY
WHY TODAY
TOMORROW WILL BE YESTERDAY
WHO CAN TELL
Why ·but· to smell
the violet tempo changes
can recall
the dewy
Prime of youth
and
buried
time

THE ANSWER'S NOWHERE
FOUND IN
RHYME!

Handwriting

Handwriting

is an essential development of calligraphy for even the Romans had a cursive alphabet two thousand years ago and the Carolingian scribes were on the verge of providing us with a cursive alphabet which might have been realised had the pointed Gothic not come along to supplant it. Here is an example which clearly shows letters becoming cursive — that is, being made in a continuous movement (m, instead of m in three strokes) and also joining one with another without a pen lift. This suggests that the passage was being written fairly quickly but with a little more haste we should have seen the letters taking on a definite slope to the right with a sharper turn at the base. The cursive hand as we know it today did not appear until the Italian scribes of the 15th & 16th centuries crystalised the system, in particular Arrighi, whose 'Operina' was the first practical manual of italic (1522).

oncedatq: propitiuf utomfqui addecationem huiuf bafilicae deuote conueniftif. interceden te beato. ilt. &cecerif fcif fuif. quorum reliquiae hicpio uene rantur amore. uobifcumhinc ueniam peccatoru urorum.re portare ualeatif · · A MEN

Seguita lo essempio delle' lre'che' pono
ligarsi con tutte'le' sue sequenti, in tal mo=
do cioe'

aa ab ac ad ae' af ag ah ai ak al am an
ao ap aq ar as af at au ax ay az
Il medesmo farai con d i k l m n u.
Le ligature' poi de' c f s f t sonno
le' infra=
scritte
ct, fa ff fi fm fn fo fr fu fy,
ft ft
ff ff ß ft, ta te' ti tm tn to tq tr tt tu
tx ty
Con le restanti' littere' de'lo Alphabeto, che'
sono, b e'g h o p q r x y z z
non si deue' ligar mai lra
alcuna sequente'

See' below an example'of the letters
that can be joined with any that follow
to wit

aa ab ac ad ae' af ag ah ai ak al am an
ao ap aq ar as af at au ax ay az
The'same can be done with d i k l m n u.
The ligatures for c f s f t are'
written
below
ct, fa ff fi fm fn fo fr fu fy,
ft ft
ff ff ß ft, ta te' ti tm tn to tq tr tt tu
tx ty
Concerning the other letters of the Alphabet,
which are b e'g h o p q r x y z z
one ought not to tie any to
the letter following.

John Howard Benson, *The First Writing Book*, Yale
University Press, London, 1976, page 16

Arrighi's manual has been translated by the late John Benson &published in facsimile. Here
is page 16 of the facsimile and the translation which closely adheres to the layout of the original.

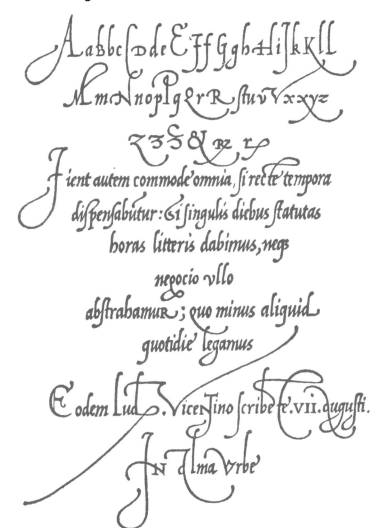

Three Classics of Italian Calligraphy, Dover Publications Inc, USA, 1953, page 28

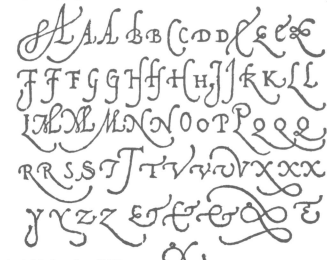

Palatino, *Libro nuovo*, 1540
Three Classics of Italian Calligraphy, Dover Publcations Inc, USA, 1953, page 153

Arrighi, *Operina*, 1522
John Howard Benson, *The First Writing Book*, Yale University Press, London, 1976, page 22

The first writing manuals were printed from wood blocks hence the contrast of stroke is not as marked as in the original manuscript. But this did not restrict the calligrapher from providing extremely flourished capitals. Here are Arrighi's capitals closely followed almost stroke by stroke by Palatino.

Egli è manifesto ... Alphabeto (calligraphic text specimen, Italian)

Three Classics of Italian Calligraphy, Dover Publications Inc, USA, 1953, page 70

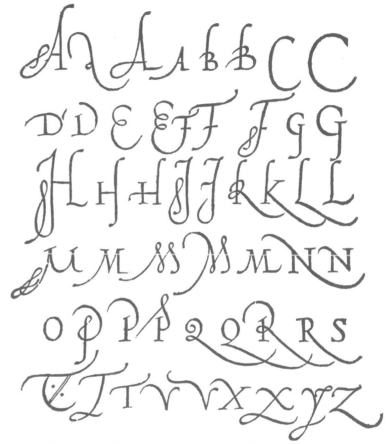

Three Classics of Italian Calligrapy, Dover Publications Inc, USA, 1953, page 77

Arrighi's manual was soon followed by that of Tagliente whose writing is rather more compressed and upright. His capitals are even more fanciful. In time this addiction to decoration became an obsession with writing masters who vied with one another to produce the most intricate flourishing. We turn with relief to the refreshing simplicity of Arrighi.

Thomaßo Spica Deli
Spinteri
Romano.

Sia con tua pace homai gentil Roßano,
Se' più non è' tuo figlio 'l Palatino,
Il cui spirto immortal sacro, et diuino
Non cape' un humil mote' ò un picciol piano.
Quanto 'l suo ingegno è' pin chiaro, et soprano,
Terren più chiar conuiengli, et pellegrino,
Quinci fu per virtù non per destino,
Meßo tra suoi dal gran popol Romano,
Onde', S'unqua di ciò prendesti sdegno,
Homai t'acqueta, che' più bel paese',
Per suo lo vuole', & è' di lui ben degno,
T'è' già non biasmo, mà ueder palese'
Quanto è' da Roma à tè' tropp'alto segno,
Puoi, per gli antichi gesti et l'alte' imprese'.

Il modo d'imparare' à Scriuere la lettera
Cancellaresca Romana,
nella forma ch'è' detta'
corrente'.
Con le sue proprie' Regole, et misure' proportionate',
Ritruouato, et Composto
da M. Giouanbattista Palatino, Cittadino
ROMANO.
Et da lui Stesso di nuouo corretto.
L'Anno di nostra
Salute',
MD LXVI.

Con Gratie', & Priuileggi.

Palatino, *Libro nuovo*, 1540

Palatino, *Compendio del gram volume*, 1566

Palatino is the third great Italian scribe whose manual (1540) is still studied and enjoyed by the enthusiasts of today. It ran into many editions and like the others was printed from wood blocks, cut to reproduce the contrast of stroke of the edged quill.

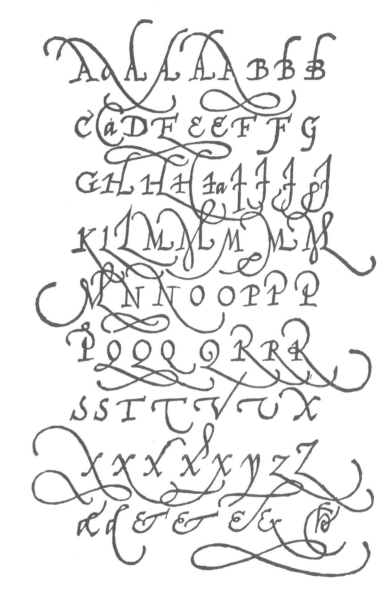

Gerard Mercator (facsimile), 1540

Here are pages from the manual by the
Flemish cartographer & calligrapher, Gerard Mercator, published in 1540

Copperplate or English Round Hand

abcdefghijklmnopqrstuvwxyz1234567890

abcdefghijklmnopqrstuvwxyz 123456789

ABCDEFGHIJKLMNOP2R
STUVWXYZ AABCEFGH
IJKLMNOPQRSTUVWX Z

The italic hand was followed by the copper plate so-called because the wood-block was replaced by engraved copper-plates to print the manuals. The effect of the edged pen gave way to the artificially contrived thicks and thins of the burin on copper & to writing with a pointed rather than an edged pen. This necessitated writing with the pen pressure constantly changing, a far from practical technique if writing is to be swift yet legible. In time this led to a simpler style being devised, without variation of pressure, using a cord line instead of 'thicks and thins'. This is an example of Vere Foster writing for children.

The above example is by

Margaret Snape (Sydney)-1982.

One good turn deserves another.

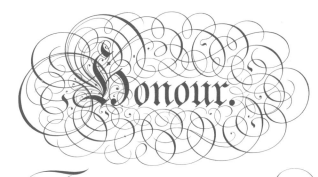

Specimens Of the Running Hand, from the Performances of the best Masters, By Geo. Bickham

Aabbccddeefffgghhbijkkllmnoppqrrrsfstttuvuwxxyyzz &

Prize exquisite Workmanship, and be carefully diligent.

It's a brave Thing to equalize Works excellently perform'd

Aaabbccddeefffgghhbijkkllmnooppqqrrrsfsttttuvuwxxyyyzz &

A A B C C D D E E F F G G b H I J K K L L M M

N N O O P P P 2 2 R R S S T T U V V W X X Y Y Z Z

As a legible and free Running hand is indispensibly Necessary in all Manner of Business, I thought proper to introduce these Examples for the Practise of Youth, and their more speedy Improvement. September 4th 1739. G.B.

George Bickham, *The Universal Penman*, 1733-41, page 163

Honour.

The Sense of Honour is of so fine and delicate a nature, that it is only to be met with in minds which are naturally noble, or in such as have been cultivated by great Examples or a refin'd Education. 1736.

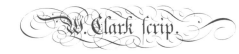

W. Clark scrip.

George Bickman, *The Universal Penman*, 1733-41, page 79

The 18th century copper-plate manuals were superbly engraved. Perhaps the most outstanding was that by George Bickham who invited many fine exponents to contribute to his book, 'The Universal Penman,' which was published in parts, beginning in 1733, and ending in 1741. The complete book consists of 212 plates.

29, Denfield Avenue, Cardenden, Fife.

4th March 1952 Cardenden 392

Dear Mr. Gourdie,

Your beautifully written letter has lain these several days unattended for which I crave your indulgence, being much occupied with work of particular importance, and letter-writing has perforce been neglected.

I have no single, no everyday style in my writing, and I pen my hand according to the deserts of the occasion, be it for the letter or the book, the journal or the note of mayfly duration. I like best the Italique hand of fifteenth and sixteenth centuries and particularly those of the sixteenth cent. both early and late. You may wonder thus why it is I write in the Eighteenth century style of Monsieur de Launay and other engravers of that brilliant epoque. I have little reasonable explanation unless it be that the Eighteenth century was my first love, and as such, cannot lightly set this style aside, although I write well in the Italian manner.

Here, then is something of my writing, which is no worse than I feared, nor yet so good as I had hoped. Still I am hopefull that you may find something about it, worthy, both of the name of good writing, and of your collection.

Yours most cordially

William MacLaren

Letter by William MacLàren, Scotland, 1952

Copper-plate for everyday correspondence and official invitations.

In honor of
The President-Elect of the United States
and Mrs. Reagan
The Vice President-Elect of the United States
and Mrs. Bush

The Presidential Inaugural Committee 1981

requests the honor of your company

at the

Inaugural Concerts

Sunday evening the eighteenth of January

one thousand nine hundred and eighty-one

John F. Kennedy Memorial Center

for the Performing Arts

in the City of Washington

Black Tie

Invitation, 1981

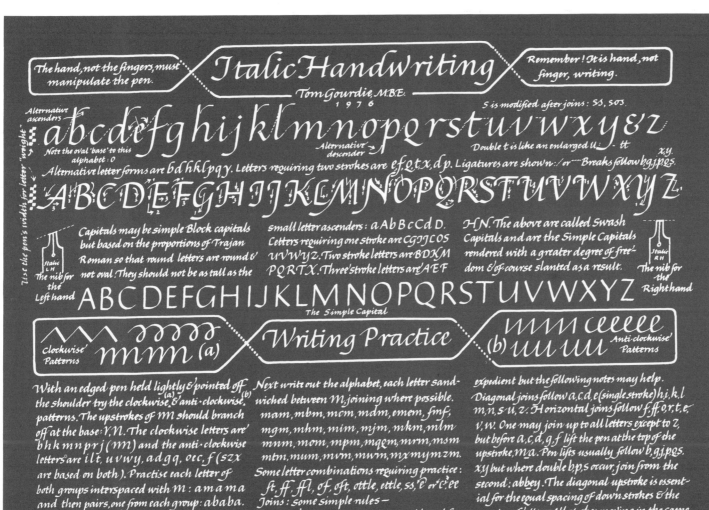

Tom Gourdie, Italic chart, 1983

This italic chart contains all the rules necessary for acquiring the italic hand. It originated in 1953 and has been constantly revised since. It not only provides a simple italic style but, with additions to ascenders, also allows one to write a more formal style (such as this) with swash capitals, suitable for more formal occasions — for wedding & party invitations, special announcements etc.

Italic handwriting today

7 Lansdown Place East, Bath.
26. 11. 1951

Dear Gourdie,

Thank you for your friendly letter. Miss Hutton had told me you had visited the Crafts Centre and I was very pleased. I hope you thought your visit worthwhile.

I'm afraid I cant add to your collection, for if I get a good piece of handwriting I need it or if it isn't quite good enough for my purposes it isnt for yours either! Instead, I am lending you the enclosures for a fortnight. Please be sure to let me have them back by that time for I want to make some lantern slides. I begin to be surprised how much the interest in italic handwriting has extended.

You may like to know that a paper I read to the Royal Society of Arts on Italic Hwtg has been printed in the Journal of the R.S.A.

Alfred Fairbank, C.B.E.

My first letter from Alfred Fairbank

We owe it to Alfred Fairbank for re-introducing the italic hand. At his suggestion the Society of Scribes & Illuminators set up a committee in 1924 to investigate cursive handwriting, and this started his campaign. His 'A Handwriting Manual' (Faber) and the Woodside Writing Cards of 1932 were followed in 1935 by the Dryad Writing Cards (especially devised for the Schools of Barking, London, at the invitation of Joseph Compton) and in 1949 by his Penguin Book of Scripts. His 'Beacon Writing' books for schools followed in 1959.

The 1932 Manual influenced my decision as a calligrapher to concentrate on handwriting and his letter to me in 1951, with an exhibition of examples of handwriting, began my campaign to establish the italic hand in Scotland. This led to the production of my own charts, books and school material in which there is a deviation from the Fairbank model to something simpler.

Before...

want to realise the splendid vision of all
visible things — wink the other eye"
 from "The advantages of having one leg

"... I like the Cyclostyle ink; it is so inky. I do
not think there is anyone who takes such a fierce
pleasure in things being themselves as I do.
The startling wetness of water excites and
intoxicates me: the fieriness of fire, the
steeliness of steel the unutterable muddiness
of mud. It is the same with people. ... When we
call a man "manly" or a woman "womanly"
we touch the deepest philosophy."
 — G.K.C. Masse Ward

Bernard Deegan

The marked difference between those two
scripts needs no emphasising. When an
interest in improving one's handwriting
along italic lines occurs it opens the door
not only to enhancing one's handwriting
but to a development of interest in more
formal calligraphy— to a study of the
historic alphabets.

Servite Priory, Kingsway East, Dundee
24 May 1972

Dear Tom,
 I enclose two examples of my writing
- "before and after". It is very kind of you to ask
me for samples and to consider them for your
new book. I had difficulty in finding any early
examples, and I hope the piece I have sent is
suitable. Perhaps the one marked would be
suitable - but I leave it to you. I hope that
the modern piece (after my conversion!) will be
all right.
 Again, many thanks.
 My best wishes to you and to Mrs. Gourdie.
 Yours very sincerely,
 Bernard Deegan.

...and after

Letter by Bernard Deegan, Scotland, 1972

Extreme busyness, whether at school or college, kirk or market, is a
symptom of deficient vitality; and a faculty for idleness implies
a catholic appetite and a strong sense of personal identity. There
is a sort of dead-alive, hackneyed people about who are scarcely
conscious of living except in the exercise of some conventual
occupation... they cannot be idle, their nature is not generous
enough; and they pass those hours in a sort of coma, what are
not dedicated to furious moiling in the gold-mill.

R L Stevenson

20 Riverdale Park North, Belfast, N. Ireland, BT11 9DL
12 January 1980

Tom : You asked me to tell you how I came to Italic. Well, my memory for things in general is a fairly poor performer but on this particular matter I think it's quite reliable.

At public elementary school I had been taught handwriting on the Vere Foster system and no doubt was a competent copyist, but I never liked the style and later, at technical school, nosed around looking for something better. I hadn't a very clear idea of what might constitute 'something better,' although I did attempt to copy from the text of printed books, with little or no effect on my everyday handwriting. Then one day – it could have been in 1938 – I chanced in the Belfast Central Reference Library on an index card that related to a book entitled LETTERING OF TODAY. I called for it and immediately struck gold, for there in the section headed CALLIGRAPHY, by Alfred Fairbank, was the lead I'd been hoping for; it was in the final paragraphs, with his brief and appreciative glance at the qualities that marked the Italic cursive hands of the XVI th century, qualities that shone out from the plates on the pages following

Letter by Frank McGrath, Northern Ireland, 1980

Frank McGrath, cartographer and calligrapher is one of the pioneers of italic hand-writing in Northern Ireland.

2

Fairbank's essay. I was particularly impressed by the informal hands of the Rev. C.M. Lamb and John Linnell and right away began the task of reforming my handwriting in line with these models – helped, of course, by the reproduction of two of Fairbank's Dryad writing cards in the same book.

It was not an ideal way to learn Italic and I've never been satisfied with my script. By the time I came across your books and such as Irene Wellington's I was too set in my ways, with bad habits deeply ingrained, to embark on a second reformation. Nowadays I'm content if I achieve a decent legibility with reasonable speed. As for beauty – and Fairbank listed this as an attribute of Italic – surely it can never be more than an accident, in the philosophical sense, in any human making of things.

I look forward to seeing you later this year.

Best wishes from me AND Bessie . . . Frank McG.

Christmas 1979

Know that we think of you and wish you well ✠ ✠

From the McGraths:
Sorcha · Aidan · Conan · Paul · Bessie · Frank

Greeting card by Frank McGrath, Northern Ireland, 1979

2536 Fourth Avenue North, St. Petersburg, Florida 33713
November 26, 1981

Dear Mr. Gourdie,

Since I saw your lecture at the St. Petersburg Society of Scribes in October 1980, I have been working on my handwriting. That demonstration is the only formal instruction I have had in handwriting or calligraphy. I can still remember how amazed I was at the way you progressed systematically from simple print-script to formal italics in one hour.

One of my foremost wishes now is to be able to teach italic handwriting. I would even like to be instrumental in convincing the local school board to institute italics in its curriculum. Toward these ends, I would appreciate any critique you could offer on my writing — either good or bad.

George Thomson could see the influence of your teaching when I wrote to him for your address. I told him how I learned, and that I am most taken now with simple black writing on white paper. I like the "everyman's art." approach rather than the more elaborate and formal calligraphy. Maybe I'll progress to that stage someday, but for now I'm satisfied to write a nice hand.

I am enclosing a copy of the Order of Worship I wrote for my sister's wedding this summer. The writing was reduced by about one-third, and the choice of papers was not mine. But I was somewhat pleased with it. (Sorry it is folded.)

Thank you again for that lecture. I feel like I was given a great gift to be taught this writing. If you should ever return to St. Petersburg, please let me know; I would enjoy seeing you again.

Sincerely,
Ron Carney

P.S.: What does "M·B·E" stand for? (I have been curious for a year now.)

Letter by Ron Carney, USA, 1981

This example by Ron Carney is remarkably controlled. His desire to keep his italic simple, without flourishing, to have a simple but elegant layout and to provide ample spacing between lines all combine to produce a work of art out of a letter. It is indeed exemplary!

Graphic Arts Workshop + Reed College, Portland 2, Oregon

Dear Tom,

How is your book coming along? I hope you are bearing
up under the immense strain — and that it turns
out as you had hoped.

The last book order I placed through the College Book Store
took three months — & then not all items came. If
I order your book in the same way, it would be impos-
sible for me to consider it as a text for my classes next
September! So, to expedite the matter, could you send
me a copy? I could send you a check or money order—
or John Howard's Benson's beautiful new calligraphed
translation (and facsimile) of "La Operina" — or
whatever you'd prefer. Who is the publisher? & what
is the price?

13 March 1955

Yours,
Lloyd

Letter by Lloyd Reynolds, USA, 1955

If your Exhibition of Italic Handwriting should
get to the United States or Canada, please let
me know. A number of Showings could be
organized in Oregon.

Thank you for writing to me — & especially for giving
me another opportunity.

Yours sincerely,

Lloyd J. Reynolds

abcdefghijklm nopqrstuvwxyyy &z
ABCDEFGHIJKLMNOPQ
RSTUVWXYZ

Letter by Lloyd Reynolds, USA

Lloyd Reynolds was the inspired leader
of the Western American Calligraphers
& was responsible for the introduction of
the italic hand to that part of the USA.
Portland, Oregon, is renowned for its
fine street lettering, resulting from the
teaching of this fine calligrapher.

Old Chapel Field, Kington Langley, nr. Chippenham,
Wiltshire SN 15 5PW
31st. December, 1981.

Dear Tom,

How you spoil me! I can
still get no reply from E. S. Perry, so I was most
delighted to receive this wonderful array of nibs
from you. You are most kind. Has the firm closed
down, I wonder? I suppose the felt-tip writing
instrument is fast replacing the honest pen.
This is very sad. Yet so many of my friends still
take pleasure in decent handwriting, & I do hope
we haven't lost Osmiroid. If you ever come to
Bath you must see the excellent collection of
calligraphy at the Crafts Study Centre
(Univ. of Bath, Holburne Museum) which we
helped to found. We have good examples of Edw.
Johnston's & Graily Hewitt's work, & we
hope soon to acquire a varied mass of Irene
Wellington's.

I hope you managed to get
a copy of "Woodland Plants" before the
edition was exhausted, twelve days after
publication.

It is hoped that a second edition — exactly like
the first, but less expensively bound, @ £21 —
will be ready by mid or late January. Robin
Garton tells us that orders are coming in
quickly, so it would be well to order direct from
him at 9, Lancashire Court, New Bond St.,
London, W.1..

Heather & Dietrich & I
send warm New Year greetings & best
wishes to you both. (What a beautiful &
rare name Lilias is!)

Robin.

Letter by Robin Tanner, England, 1981

Botanic illustration by Robin Tanner

Robin Tanner, a pioneer of the italic hand in Great Britain

Old Chapel Field, Kington Langley,
near CHIPPENHAM, Wiltshire.
28th. May, '52.

Dear Mr. Gourdie,
Your letter about your proposed show
of handwriting has just reached me.
I'm afraid I make no claim to being a
scribe, and when you see this heavy
hand - which has been my everyday
one for some years - I doubt whether
you will feel inclined to include it.
You ask me, too, to show you the alphabet
I use ; it is not entirely consistent
but is more or less as follows :—
AABCDEFFGHIJ
KLMMNNOPQR
STUVWXYYZ
abcdefghijklmnopqrrst
uvwxyz3 1234567890

Letter by Robin Tanner, England, 1952

Kington Langley, Chippenham,
WILTSHIRE.
17th. March. 1962.

Dear Tom,
I am not sure whether I shd. address this
to England or Scotland ?
It was very kind of you to send all these
good samples of pens, which I will display
at Dartington. It will be frustrating,
though, if people find it hard to buy these
easily in the shops ; I am still searching
for a medium ɑ broad "twisted" lefthand
nib ! It is exasperating.
The Lettering set is admirable. I can't
quite see the purpose, however, of the
416 R M T nib ? – at least, not for an
italic writer, surely ?
Your Puffin Lettering Book I have
already introduced to many people,
for it is an amazing halfcrown's worth.

*see over :

Letter by Robin Tanner, England, 1962

These examples of Robin Tanner's hand
show little change in over thirty years
and also illustrate what can be done with
an edged pen by a left-hander. Robin is
also a gifted botanic illustrator.

11 Dorchester Drive, Bedfont near Feltham, Middlesex

12 November 1969

December 23, 1957

Dear Mr. Gourdie,

Thank you for your letter of the 6th.

I think that, if my Maidstone Map were reproduced, it might mislead the public into thinking that it represented an example of the standard of work of a Craft Member, whereas, of course, it was an amateur (and inaccurate) attempt to provide SSI members with a rough and ready "how to get there" sketch maps, accompanying the circular. Furthermore it was based on a sketch by Miss Mildred Ratcliffe, so it isn't even original. So I think we'd better say 'No'. Sorry!

P.T.O

Dear Paul

Thank you for sending me the 'fine' Iridinoid pen nib with which I'm finally writing to you. This size is a bit larger than my usual hand, but I find the pen very smooth, sturdy and holds the ink wonderfully. To put it simply, I like it very much.

As you might have guessed, work, social activities and the approaching holidays have been the cause of the delay in answering your letter. Meanwhile, thanks to you, Mr. Tom Gourdie has sent me samples of broad, medium and fine nibs from Scotland; they will be fun to try, so I've got pleasure ahead of me. Therefore thank you again for a happy introduction to Iridinoid.

Best wishes to you and your wife from

Sincerely yours,
Jeanyee Wong

Letter by John Cackett, England, 1969

Letter by Jeanyee Wong, USA, 1957

The late John Cackett wrote a most controlled italic – as fastidious as himself! Jeanyee Wong's italic is not so much a cursive hand as lettering but what superb lettering! Both are fine examples of calligraphy put to everyday use.

Dear Mr. Gourdie,

Thank you so very much for your kind attention concerning our current textbook problems. It was such a delightful surprise to receive your letter...

I had mentioned to Mr. Ebsen that I wanted to use Handwriting for Today as a text, but when he informed me that Italic Handwriting was again in print, I was thrilled! I find it so explicit, with both "right" and "wrong" examples, that I can't think of a more helpful guide for students of Italics.

According to the Canadian Pitman Publishers, only Handwriting for Today is on their list. Because of various problems we've encountered trying to obtain books, St. Lawrence College ordered only five copies of Italic Handwriting! A friend, Mrs Dorin, owner of a local shop, Books and More Books, has placed orders for each of your books, including Improve Your Handwriting.

I can't begin to say how very much we appreciate the help that both you, and Mr. Ebson, have given us. I do hope we can convince the Pitman to stock your fabulous books in Canada!

Yours sincerely,
Dorothy Johnson

Letter by Dorothy Johnson, Canada

This is a very fluent yet controlled italic hand, with just enough flourishing to make it most attractive.

Thomas Ingmire FEB 18 '78

Dear Thomas Gourdie,

Thank you very much for your letter of congratulations. I felt honoured receiving it. As to your book, I would be interested in submitting some work for it. Do you want alphabets specifically? Or will a completed black and white panel do? I have a piece from the Rubaiyat which I sent to the SSI - I could send a copy of it to you - Otherwise I will complete a few alphabets. I may not get them to you for about a month. If that doesn't meet your schedule please let me know. I passed word of your upcoming trip to the Friends of Calligraphy. I imagine you will hear from someone soon. Again many thanks,

Thomas Ingmire

Letter by Thomas Ingmire, USA, 1978

This exuberant example by one of the younger USA scribes is typical of the vitality of his calligraphy.

Tom Gourdie
3 Douglas St.
Kircaldy - Scotland

50 Hillsboro Ave.
Apt. 807
Toronto - Ontario
Canada

Servite Priory, 500 Bury New Rd., Salford M7 0WP
26th July 1981
PHONE: 061-792-2152

Dear Tom,

I often wonder how you and Lilias are, and how your handwriting "gospel" is going on. It seems a long time since we last met. I do hope that you and Lilias are well.

I am hoping to go to Scotland for my holidays in September and I was wondering if it would be possible to pay a visit to you and Lilias during that time. Would Monday 28th September suit you, I wonder, or perhaps the Tuesday? I look forward very much to seeing you again.

Best wishes to yourself and to Lilias.
Yours very sincerely,
Bernard

Letter by Bernard Deegan, England, 1981

Dear Mr. Gourdie: This letter is inspired directly by your picnic plate alphabet so you must be prepared to suffer the consequences & read in the round. I was so pleased to receive your letter. Your correspondance must be considerable. However since you're providing my workshop in day since your 2 day workshop in calligraphy, you can imagine what encouragement you're providing. Now I'll stop writing - this circle is killing me by degrees. (Hmmm... American humor.) local, like-minded people. Now I'll stop settled, will search out the from Montreal to Toronto & when I'm a bit education in calligraphy represents one-half of my formal Sincerely

Natalie Axelrod
Oct 29, 1976

Letter by Natalie Axelrod, Canada, 1976

Letters of all kinds make one's correspondence something to look forward to — circular designs, different ways of commencing a letter and the placing of the address, all can be individual.

Dear Mr. Gourdie,
I am a Lecturer at the Leicester College of Art and this letter is written to you to request a sample of your handwriting. I wish to include this in an exhibition of Lettering which I am preparing for Monday 15th January when my lecture to the A.T.D. Students is to be devoted to fine Lettering and Writing. I shall be very grateful if you would concede to my request.

Yours sincerely,
John M. Lancaster.

Letter by John Lancaster, England

The page of mine that you used looks good – I had forgotten about it –

CON
GRAT
ULA
TION
S ON
YOUR
BOOK
CALLIGRAPHIC
STYLES

I got my copy –
it's wonderful, especially
the way you analyse
the basic forms.
That is what did
so much for my first
Italic efforts so
many years ago &
now I am glad that
it extends (in this
new book) to all
the historical hands.
As usual your examples
are strong and clear.

I've sold (as well as bought)
lots of copies for you.
Let us hope for many
more printings.
You must be happy about it.

Mr. Tom Gourdie
3 Douglas Street
Kirkaldy, Fife
SCOTLAND

Letter by David Mekelburg, USA, 1979

January 1977

I adopted the italic style of handwriting in
January 1975 and taught myself initially
from a book by Tom Gourdie – "Handwriting
for Today" which must surely be the best
bargain of any instruction manual on the
market.
This is a sample of my everyday hand and I
emphasise that it is written at normal
handwriting speed and in no way laboured.
I try to keep the hand simple and do not permit
myself to introduce too many flourishes.
I use this hand for all my handwriting, even
memos and telephone messages, and personally
I find that the speed at which I write helps
to maintain fluency and movement.

Duncan Gilfillan
15th January 1977

Letter by Duncan Gilfillan, 1977

The layout of letters can be as imaginative as this
by David Mekelburg (USA) or as conservative as
Duncan Gilfillan's note. The letters which follow
show individuality of interpretation of italic.

7, Coronation Grove, Swaffham, Norfolk.

3 : xij : 57.

Dear Mr. Gourdie,

Many, many thanks for your kind & complimentary letter, & for your added kindness in sending me your handwriting chart which, I can assure you, will prove most useful.

May I add that I do admire your delightfully free, cursive hand. Would that mine appeared as free, but, due to my left=handedness, perhaps, this is as cursive as I can get! I get along quite quickly, how=ever, & stick to this style as it suits my hand. Perhaps, too, I am a stickler for

2.

tradition, and would honestly say that the italic of Amphiareo, Ascham & Dod-ington appeal to me more than that of Arrighi or Tagliente, & it is on the hands of the former that I have based my own.

I am not unmindful of the praise bestowed upon me in your charming letter, which, from you, I accept as praise indeed, & I value your comments very highly.

You ask if I teach. I am not a teacher by profession, but often wish I were! I hope in the New Year, when my proposed cam=paign gets under way, to teach the italic hand to those intrepid souls who profess themselves keen enough to learn it [and here your chart will be of great assistance].

3.

As for myself, I appear to be a man of many parts! I am almost 40 years young, very happily married, no children, a cost accountant by profession but not by choice, artist [mainly water-colour because it's the more difficult], poet, bibliophile, nature-lover & a great admirer of vintage cars! I started a quite successful art group here some years ago, but it died slowly & painfully due to jealousy and lack of exhibition space.

I first became interested in the italic hand after buying Alfred Fairbanks' "Book of Scripts", abandoned painting, & turned to calligraphy, studying everything I cd. lay my hands on. And I find it most

Letter by Eric Drake, England, 1957

Eric Drake's italic is superb by any standards but even more so when it is realised that he is left-handed which involves holding the pen pointed towards the body with the paper turned down to the right. A left-oblique nib is suggested for the left-hander.

Pen & paper angles.

Dear Mr Gourdie

Thank you so much for your letter and card, both of which fascinate me. I think your form and fluency are magnificent. As you can see I am still battling and am quite sure I shall never be satisfied — which is as it should be I suppose. Lately I have been bothered with angle of slope. Originally I practised vertical and then switched to a slight obliquity. Now I am back to vertical again which I think I prefer. It all seems to boil down to paper angle — this is written with the paper square in front of me and slightly off centre to the right. With the paper tilted and consequently writing with a slant I think I can go a little faster but find that I pay for this advantage with decreased discipline. To quote Oscar Hammerstein's King of Siam in 'The King & I' ~ ''Tis a puzzlement!'- but an intriguing one I must admit.

Letter by John Upcot, South Africa

38 Norland Square. London
23rd April 80.

Dear Tom.

Thanks for your letter which arrived today. I was very pleased to hear from you.

Bruce and I leave for home on May 12th. So I will miss your calligraphy exhibition. I would love to have seen it and I'm sure it will be a great success.

Before our return Bruce and I plan a "flying" visit to Scotland. (Tues 6th Wed 7th.) I will give you a definite time soon. I hope you will not be upset if we only pop in for a few hours before going further north.

Regarding your Australian tour I know no more. Have you contacted Miss Braithwaite in Tasmania? I gave you her address. We should also write to Christopher Davidson in Victoria. We could go to Victoria and Tasmania after visiting N.S.W. The 18th August to 25th August would be suitable.

Could you give me back my letter from N.S.W. Have you confirmed with N.S.W.?

Letter by Barbara Nichol, Australia, 1980

346 The West Mall ~ Apt. 504, Etobicoke, Ont. Canada.

M9C 1E5.

March 29, 1976.

Dear Mr. Gourdie:

Again I have the pleasure of acknowledging one of
 your letters ~ March 13 to be exact. I'm sorry to
 be so slow in answering your question however
 I'm still being bothered by the after effects of
 the flu & my energy has been at a low ebb.

Yes, I obtained "Handwriting for Today" in Toronto
 from Pitman. Whenever possible I deal directly
 with the publisher as the service is usually
 better than at a bookstore. They also have "Improve
 Your Handwriting" which I hope to get later. As
 you say it is much more expensive so I'll have to
 be patient for awhile.

I certainly wish you luck with the Ottawa Board of
 Education. To be quite honest with you I can't
 imagine a more difficult undertaking than

Letter by Canadian calligrapher, 1976

Postfach 619. Herm.-Föge-Weg 11
D-3400 Göttingen / W.-Germany

29. June 1977

Dear Tom Gourdie,
 I was very glad of your last letter and to hear of your
activities, now even in America, lecturing on your
methods of teaching handwriting and I thank you
very much for your Italic chart and the charts of the
Simple Modern Hand. I am always very interested in
your publications. I take much pleasure in your books.
I have permanently one of them on my writing - table.
I like my exercises. This letter is written with a Platig-
num fountain pen >fine<, but this pen is perhaps
somewhat too thick for quick handwriting in normal
size. Just I have spend some holidays at the sea,
but also there I had some of your instruction books
with me.

 Is there a chance for a handwriting book of you for
German children and adults? In my letter of 21st
January 1976 I mentioned some publishers who

Letter by West German calligrapher, 1977

Two examples which display very similar characteristics due no doubt to the
fact that both hold & manipulate the pen almost identically.

2.

teacher and I've never quite felt I qualify. The closest I've come to it are talks and workshops.

I do hope we can arrange for you to come to Denver on one of your future trips. Also that it will be possible for us to bring you down from there to Woodland Park for two or three days at least before you travel on. We are about a half hours drive from the Springs so that Arthur and Jean Davies would be readily available for nice get-together.

It is my hope this reaches you before you leave.

At any rate may you and Lilias have the best year ever in 1978 and

A Bientôt

Jim

Letter by James Hayes, USA, 1977

2401 Chelton Rd.,
Colorado Springs, Co., 80909
U.S.A.

Hello, Tom : Sept. 3, 1979

What a fine surprise just came in the mail ; your new book, "Calligraphy for the Beginner." I just don't know how you get so much done .. when do you sleep?

Here's hoping one of these days soon I'll be able to persuade the author to inscribe a few words in the flyleaf.

Thanks so much Tom for your thoughtfulness and please give our very best to Lilias.

Art & Jeanne

P.S. Thought of you both this summer when we went up to Cripple Creek one week-end to see the old melodrama at the Imperial Hotel. Didn't get to Victor, though.

Letter by Arthur Davies, USA, 1978

Two examples of vigorous italic hands, the one on the left is by James Hayes, one of America's finest calligraphers and that on the right by Arthur Davies, a foremost designer of greetings cards which are splendid vehicles for his calligraphy. Incidentally, both reflect their personalities !

HOW BEAUTIFUL UPON THE MOUNTAINS ARE THE FEET OF HIM THAT BRINGETH GOOD TIDINGS, THAT PUBLISHETH PEACE; THAT BRINGETH GOOD TIDINGS OF GOOD, THAT PUBLISHETH SALVATION: THAT SAITH UNTO ZION, THY GOD REIGNETH!

ISAIAH 52:7

Best wishes for your peace and happiness throughout Christmas and the coming year from James and Nellie Hayes.

James Hayes — one of America's best-loved scribes whose bookplate & Ex Libris designs are justly renowned for their magnificent roman & italic.

Designs by James Hayes, USA

Not fair, I suppose, to try to wriggle out of it! I'm not proud of my writing. I began too late; I write too much, and too often too fast; my pen-hold is un-orthodox, my posture unhygienic. I wonder sometimes whether I am a scribe - or a pharisee.

But at all events I write freely. I wd rather advance swiftly with my own poor pen than creep laboriously in the foot-prints of even Arrighi himself.

Wilfrid Blunt

Letter by Wilfrid Blunt, England

Aabbⓒde Ḗ Ff Gghḥ Ijkkll
Mm Nnopⓠ ꝗꞃR ʃtuv Vxxyz
ꝣꝫ ꝫ & ℞ ꝝ

fient autem commode'omnia, ʃirecte'tempora dispensabitur: ⓖi ʃingulis diebus ʃtatutas horas litteris dabimus, neꝗ negocio vllo abstrahamuꞃ; quo minus aliquid quotidie' legamus ..

E'odem Ludo. Vicentino ʃcribete'.vii.augusti.

In Alma Vrbe'

John Howard Benson, *The First Writing Book*, Yale University Press, London, 1976, page 26

Wilfrid Blunt was for many years Art Master at Eton College. Sir Sydney Cockerell lent italic material to Eton for an exhibition, and this material inspired Blunt to introduce italic handwriting to the school. Wilfrid Blunt was also responsible for one of the best books on italic, 'The Sweet Roman Hand'. But despite his enthusiasm he has never condoned slow, tortuous italic, and has opted for a speedy personal interpretation of the style.

ABCDEFGHIJKLMNOPQRSTUVWXYZ

abcdefghijklmnopqrstuvwxyz

1234567890

join diagonally from
acdehiklmnuz

join horizontally from
fortvwx

do not join from
bgjpqsy

do not join to
bfhklz

1 stroke	2 strokes	3 strokes
CIJLOSUVWZ	BDGKMNPQRTXY	AEFH

all small letters are made with one stroke except
defptx

Published by the Canadian Society for Italic Handwriting · Free to members · Price to non-members 25c

Chart published by the Canadian Society for Italic
Handwriting

Gillam, Man., Canada
May 7, 1980

Dear Mr. Gourdie

You probably don't remember me but I wrote to you many
years ago. You actually were kind enough to reproduce my
letter in the 1974 edition of your handbook (p.36).
I used to receive the Journal of the SIH, but a few years ago
I neglected to renew my subscription. Could you provide
me with the name and address of the present secretary
of the Society for Italic Handwriting. I would like to
renew my membership. I hope you don't mind my calling
on you to solve this little problem of mine.

Yours sincerely,

(Rev.) F.J. Lapalme

Letter by Father Lapalme, Canada, 1980

This chart and the letter from Father La —
palme both illustrate the enthusiasm and
interest in Canada for the italic hand.

Lecture/Demonstration by Georgianna Greenwood ❧ Friday 5 March 1976 at 7:30 pm

San Francisco

Public Library ❧

Merced Branch

155 Winston Drive

& 19th Avenue

Calligraphy

F R E E ❧ funded by the Friends of the San Francisco Public Library

Notice by Georgianna Greenwood, USA, 1976

Calligraphy by Walter Kach, Switzerland

Calligraphy by Walter Kach, Switzerland

Begin difficult things while they are easy. DO great things when they are small. The difficult things of the world must once have been easy; the great things must once have been small...... A thousand mile journey begins with one step. LAO-TSE

GLORIA IN EXCELSIS DEO

TURENNE:
You must love the
soldier
if you wish to
understand
him
and understand him
if you are to
lead him.

R
S
A

IT CAME UPON THE MIDNIGHT CLEAR,
THAT GLORIOUS SONG OF OLD
FROM ANGELS BENDING NEAR THE EARTH
TO TOUCH THEIR HARPS OF GOLD:—
'PEACE ON THE EARTH, GOOD WILL TO MEN,
FROM HEAVEN'S ALL GRACIOUS KING!
THE WORLD IN SOLEMN STILLNESS LAY
TO HEAR THE ANGELS SING

Calligraphy by Stuart Barrie, Scotland

the nature of God is a circle of which the centre is everywhere & the circumference is nowhere

thankyou

Calligraphy by Ieuan Rees, Wales

One Year is sufficient to behold all the magnificence of nature, nay even one day and one night for more is but the same brought again. This sun, that moon, these stars, the varying dance of Spring, Summer, Autumn, Winter, is that very same which the golden age did see.

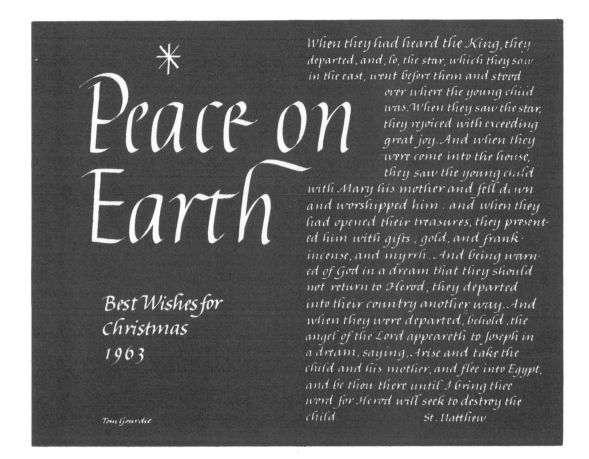

Peace on Earth

When they had heard the King, they departed, and, lo, the star, which they saw in the east, went before them and stood over where the young child was. When they saw the star, they rejoiced with exceeding great joy. And when they were come into the house, they saw the young child with Mary his mother and fell down and worshipped him: and when they had opened their treasures, they presented him with gifts; gold, and frankincense, and myrrh. And being warned of God in a dream that they should not return to Herod, they departed into their country another way. And when they were departed, behold, the angel of the Lord appeareth to Joseph in a dream, saying, Arise and take the child and his mother, and flee into Egypt, and be thou there until I bring thee word: for Herod will seek to destroy the child. St. Matthew

Best Wishes for Christmas 1963

Tom Gourdie

Happy christmas, from Ieuan, Barbara and 1974 Victoria

Calligraphy by Ieuan Rees, Wales

CHRISTMAS GREETINGS

Calligraphy by Tom Gourdie, Scotland

Christmas cards are a very useful medium for the practice of one's calligraphy.

Calligraphy at the Cottage

CALLIGRAPHY IS THE ART OF HAND LETTERING WITH BROAD EDGED PENS

Classes are now being held at Middle Harbour Recreation Centre 8 · Hale Rd. Mosman. Vacancies now exist in the Thursday daytime class from 1pm. till 3pm. Instructor Ethna Gallacher.

RING THE COTTAGE 908 · 2102 FOR ENROLMENT DETAILS

Calligraphy by Ethna Gallacher, Australia

Certificate of Achievement

Calligraphy by Margaret Snape, Australia

The Dare Group of Companies

Calligraphy by Margaret Snape, Australia

Snape Gallaher Graphics

Yes!

I'm interested in attending the

TOM GOURDIE WORKSHOP

Please send me details of content · cost · venue · dates · ett, as soon as they become available. I understand that this is not a registration form – merely an enquiry.

Mail to ASC secretary G.P.O. Box 35. Glebe NSW. 2037

NAME _____

ADDRESS _____ POSTCODE _____

STATE _____

TELEPHONE _____

Calligraphy by Ethna Gallacher, Australia

abcdefghijklmnopqrsstu

ABCDEF vwxyz GHIJKL

MNOPQRSTUVWXY&Z

The alphabet is based on the two natural movements of handwriting
MM and UUU
which must be fully mastered before beginning to learn the alphabet. All the letters are so devised that they flow smoothly one into the other as far as possible, but some do not join and they are
b g j p q s x y.
They, however, serve to provide natural 'breathing' places where the pen is lifted and the hand allowed to relax briefly.
Diagonal joins follow a c d e h i k l m n u and horizontal joins follow f o r t v w to most letters except e which, except when it follows f, should be left unjoined:
oe, re, te, ve, we
The only looped letters are e f z, but use the simple forms of f & z when there is no need to loop:
for, jazz
The capitals are three quarters as tall as the small letter ascenders: Ab Cd E f G. The capitals may be given swash characteristics by writing the block capitals more freely:
A B C D E F G H I J K L M
N O P Q R S T U V W X
Y & Z
This style is suited to the writing instruments of today—to ball-points and fibre-tips etc. It is the style featured in my 'Puffin Book of Handwriting' 'I Can Write' (my school scheme published by Macmillan Education)' Handwriting Made Easy' (Taplinger. USA) & Teaching Children to Write (Macdonald Publishers Edinburgh)

The Simple Modern Hand by Tom Gourdie

This is a variation of italic which does away with e in two strokes and introduces a looped f and z when those letters are joined. This alphabet and style of writing were introduced to my pupils as an easier italic style in 1960 and this has now become internationally known as the Simple Modern Hand.

The Swedes have suggested it as the logical development of italic from the Fairbank model in their book for teachers 'FB Handskrivning 1971/72'. Interest in it has spread to the USA & Canada, Australia & New Zealand and the pen manufacturers (Osmiroid & Platignum) have all but plagiarised it. It is, of course, an italic style devised particularly for the writing tools of today

Numerals

1234567890 Simple numerals using the Mitchell script (or ball-point) pen.

1234567890 Numerals written with the broad lettering pen.

1234567890 Numerals to match the alphabet on page 26.

1234567890 Numerals to match the roman alphabet.

1234567890 Common variations in size of numerals.

The proportion of the numerals (width of stroke to height) should match that of the alphabet with which they are used.